The Complete Guide to
ORGANISING
and STYLING
PROFESSIONAL
PHOTO SHOOTS

APPLE

This edition published in the UK in 2012 by Apple Press
7 Greenland Street
London NW1 0ND
www.apple-press.com

10 9 8 7 6 5 4 3 2 1

Printed in China by 1010 Printing International Ltd.

ISBN: 978-1-84543-490-8

Art Director: Tony Seddon
Design: Studio Ink

The Complete Guide to
ORGANISING
and STYLING
PROFESSIONAL
PHOTO SHOOTS

Peter Travers and Brett Harkness

APPLE

CONTENTS

SECTION 1
ORGANIZATION AND SETUP 8

INTRODUCTION

In photography, as in life, you make your own luck. But your luck, and the chances of a successful photo-shoot, will be greatly increased if you're fully prepared. By doing all you can to ensure your shoot runs smoothly, with back-up options if (or more likely, when) everything doesn't run according to plan, you'll be able to get good results whatever the situation.

Whether you're a student or enthusiast looking to add pro-level photos to your portfolio, a semi-pro who's building up their client base and needs to know how to handle difficult photographic assignments, or a professional photographer looking to improve your working practices, this book will help you become a better photographer.

This book is also an essential guide for creatives and people regularly involved with professional shoots, such as art directors, designers, stylists, set-builders, and models. This is your one-stop handbook to ensuring smooth-running photo-shoots that deliver professional results in a timely and cost-effective way.

Here, you'll find expert advice and tips on planning a photo-shoot from concept to completion. In our book you will find direction on everything from booking and arranging a studio space to briefing stylists, sourcing props, building sets, casting models and clearing model releases, liaising with creative and photographic agencies, as well as guidance on directing shoots and model poses.

This book also covers essential photography equipment, how to shoot like a pro, and how to approach professional photography for food, people, products, interiors and gardens, and action shots, plus key post-production and image-editing techniques.

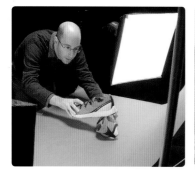

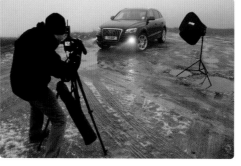

Far left and left > **Learn professional techniques for tackling studio and location shoots—whatever the weather.**

Right > **Become skilled in the ways of pro shoots and gain confidence to approach a variety of photography subjects—from people and products to food and gardens.**

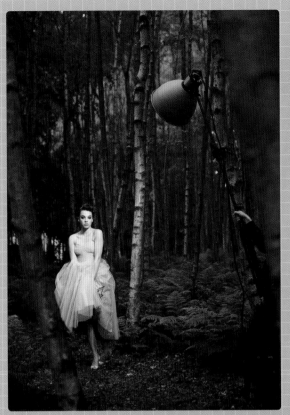
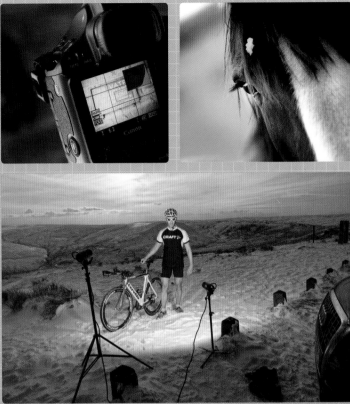

SECTION 1
ORGANIZATION AND SETUP

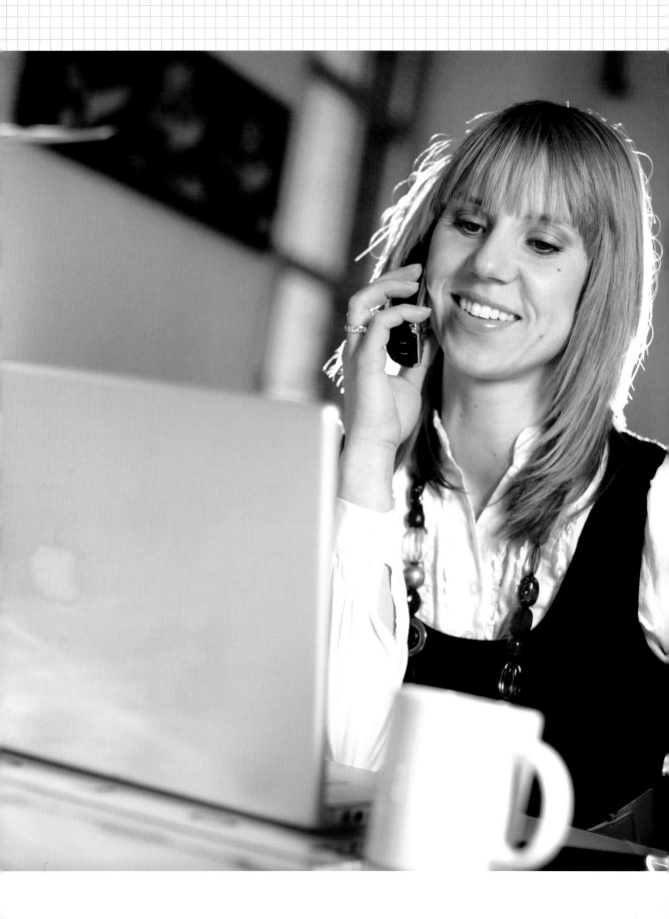

1.1

THE BRIEF

WRITING THE BRIEF

Successful photo-shoots begin with the brief. A brief is an outline of the project with—among other details covered in this chapter—instructions from the client in terms of what they want to achieve on the shoot, including specifics on the photographic style and standard they expect, and a full shot list and schedule.

We'll be examining the brief from the point of view of a photographer who's been booked for a studio portrait shoot, but whatever your role in the project, it's important you're able to compile a comprehensive brief (also known as a "call sheet"). Done correctly, it will make your job—and everyone else's—much easier throughout the course of the project and on the big day itself.

Photographic style

There's nothing worse than an indecisive client who gives you an ambiguous description of the style of photos they want. Never gamble and go into the shoot with a vague idea of what you think they want—chances are they're likely to be envisaging the opposite of whatever you produce, creating a stressful situation for you to rectify as the clock keeps ticking.

It's much better to meet with or email the client before the shoot and show them photos from your portfolio or scrapbook that you feel fit their concept. Alternatively, get them to show you examples of images they like and which fit their brand; either way, it's essential that you both agree on a clear photo style before the day of the shoot.

However, not all clients know which style of photography is right for them. This is exactly why they hire a professional photographer—for you to provide the creativity and style that you feel fits them best. You'll find that 90 percent of the time the client will go for how you've captured them or their products, rather than their (quite possibly) more elementary ideas.

Left > It's your job to advise your client by suggesting a variety of photographic styles that not only suit their brief but their brand too.

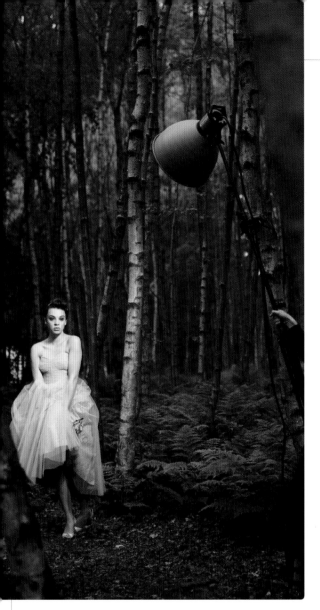

Left > Always aim to build good
working relationships with everyone
from clients to models, as one job
can lead to another.

Good photographers are good listeners. So listen first, speak second, and then ask appropriate questions: What style of photography are you looking for? How and where will the photos be used? What's your budget? When would you like to book the shoot for? Is the shoot to be in a studio or on location? Would you like me to cast and book the models? Do you want me to source the products? What about props? What about the stylist and hair and makeup artist?

Business relationships

Being informed and asking the right questions reassures clients that you can do the job—and do it well. There will, of course, be a first time for every shoot, but if possible, it doesn't hurt to mention previous assignments and subtly show off your experience, demonstrating how your past projects are similar to their new project. This reassures the client that you're the right person for the assignment.

Business is all about relationships. If you can impress clients and build a good relationship right from the beginning, you'll be off to a good start. Be as helpful as possible, be friendly and be yourself, but always remain professional.

One job can lead to another, so it's always good to be friendly and to stay in touch with clients. That way they'll remember your name, your work, and hopefully recommend you to colleagues, clients, or friends and family.

THE CLIENT

Whether you're photographing people or still-life objects, it's imperative that you approach every photo-shoot with the same professional and courteous attitude. Regardless of your subjects, you will always be dealing with the all-important client.

Always be interested in what your clients have to say and try to be interested in whatever it is they want you to photograph—if it's important to them, then it's important to you.

← 14
→ 15

MEETINGS

You only get one chance to make a first impression, so make sure it's a good one when you greet the client at your first face-to-face meeting.

It can be daunting when you initially meet clients—especially rich and powerful ones. How you handle yourself in these meetings can make or break the deal. The key to a successful meeting is a positive, passionate attitude, and being fully prepared. Clients want people who have a passion for what they do and who care about their own business, as it shows them you'll care about their business too. So do some homework and undertake some rudimentary online research about your client so you understand their business and the way they operate. If possible, also try to find out what you can about the individuals you'll be meeting.

Different clients often require a different approach and tactic. Bear this in mind when you're meeting commercial, lifestyle, fashion, editorial, or advertising clients—you may need alternative approaches each time.

For each meeting, always ensure you come primed with a professional portfolio, a good selection of photo and styling ideas, and some location suggestions. A bulging contacts book never hurts either.

Dress to impress

You can learn a lot about someone by the way they're dressed. It may seem an exaggeration to stress the importance of dressing appropriately, but if you arrive for a meeting or on set in sandals, Bermuda shorts, and a T-shirt, it could give people the wrong impression. Clients may think you don't take your work or their business seriously.

On the other hand, if you've got a photo-shoot with a cool, creative company, and you arrive overdressed in a suit and tie, they're likely to think you're not the right fit for their project. The trick is to dress so you feel comfortable. "Smart casual" (shirt with a collar, smart jeans or chinos, and shoes), will usually fit in with most crowds and companies.

Above > **When meeting clients, ensure your portfolio is up-to-date with a good selection of glossy photos that show off your range of photographic talents.**

Right > **Photo-shoots require comprehensive planning, so prepare to spend time making arrangements including; finding locations, booking models and stylists, and sourcing props.**

SHOT LIST AND LOGISTICS

When discussing the shot list with the client, ensure the list is comprehensive, yet feasible, and arrange it in order of priority as it's rarely possible to get every shot. Shoots invariably take longer than expected and if shooting outdoors, the weather and location may determine what happens.

Include notes on models and stylists, any props needed on set, plus start and finish times for each shot. For each different photo and setup, note down the camera, lens, and lighting you'll use—if you have an assistant, get them to set up each shot before you've finished the previous one in order to maintain momentum on the day.

Also make a note of planned exposures and lighting setups to fit the shot list, such as: f/9 at 1/200 sec and ISO 100, with two lights; an umbrella from the right, a soft box from the front, with a white reflector on the left to bounce a little light into the face as needed.

On the day of the shoot you may well deviate from the shot list—the subject or client, for example, may have some good ideas to help drive and improve the images. So be prepared for change and embrace it.

Logistics

Once you've been commissioned for the assignment you can start making arrangements. Book a studio that you've either used before or know will be the right size for the project—if possible, make sure it's conveniently placed for your client. Be aware that these costs will need to be approved by the clients. If you have your own studio and it's suitable, use it.

There are always more to logistics; if it's an outdoor shoot, who's responsible for picking the location(s)? What is Plan B if rain stops the shoot; reschedule or relocate to an indoor venue? Who's booking and briefing the models and stylists? If it's you, use respectable and reliable model agencies, giving your client a choice of three or four shortlisted models and the final say. Don't forget your model release forms. Do you need specific props and elaborate sets built for the shoot, or can you use what the location has to offer? Try to keep the set as simple as possible unless the client/brief demands outlandish props or has specific requirements.

PRO TIP!

Be pragmatic. If you could be on a lucrative shoot instead of spending time making arrangements for a future project, consider hiring a reputable creative agency to handle the admin for you or delegate it to a colleague or manager in your studio/office to deal with.

COPYRIGHT AND LICENSES

At the commissioning stage of an assignment, photographers should always discuss image copyright and licenses in order to avoid complications or disputes further down the line. Copyright is the legal right of the photographer or client to control the use and reproduction of the original creative works.

In the modern world of professional photography, thanks to the increasing number of potential media in which an image can be used, copyright has become a significant factor when negotiating a shoot with a client. It's important to understand the value of retaining copyright in everything that you shoot.

The copyright automatically defaults to the originator of the work—the photographer—but in an increasingly competitive industry, inexperienced photographers are willing to sign away their copyright to please important new commercial clients. Try to avoid this if at all possible.

Licenses

A license is an official, legal document that gives you/your client permission as to how, where, and when the images (shot by the owner of the copyright) can be used.

It's imperative you discuss with your clients exactly how your images will be used and draw up a license that covers this. The four main factors to consider with licenses are; usage (such as advertising, public relations, or editorial), how long the license will run (such as 6–12 months), if images are to be used in print and/or on a website, and, finally, the territories covered under the license (such as North America, Europe, or the world).

It's usually possible to negotiate a deal with the client that grants them a license to use the images in the way they desire and for a period of time that suits you both, leaving you the option to then resell your images elsewhere after an agreed timeframe.

It may be that at some later stage the client wants to use an image for purposes outside the agreed license—in a billboard campaign for example. In which case, the usual approach is to negotiate an additional license for the extra usage.

Left > Before photo-shoots take place, resolve the issue of licenses with clients to avoid complications or misunderstandings later.

HOW TO USE THE BRIEF

Look on the brief as your bible. It will tell you all you need to know for the forthcoming shoot. It's not only your guide, however, it also contains all the essential information for everyone else involved in the shoot.

Timetable

Create a schedule of who's doing what and when. Write down the date for completing casting and booking the model(s) and a hair/makeup artist. Block in completion dates for booking set builders and stylists, studios, or picking locations. All this needs to be finalized at least 7–10 days before the shoot date.

Make any travel and accommodation arrangements well in advance including hiring cars or booking airline tickets. In the brief, note down the various times everyone has to arrive at the shoot—for instance, models and hair/makeup artists usually need to arrive first, so they're ready to be photographed according to the shot list.

Add your deadlines for getting processed photos to the client, and find out how they're to be sent (such as via FTP or on disc). Note whether images are to be saved as JPEGs or TIFFs, and include any special requests such as black-and-white conversions or HDR treatment of specific shots, or any special Photoshop retouching requirements.

Circulate the brief

Make sure everyone involved in the project is emailed a copy of the brief as early as possible so that they can prepare and make any necessary arrangements for the big day. Include everyone's job title and contact details on there too. Put key decision-makers at the top, with assistants and administrators at the bottom.

Above > Being organized is the key to a successful shoot; email the brief to all involved so everybody knows what's expected of them.

CHECKLIST

→ Write the brief

→ Agree photography style

→ Build business relationships

→ Prepare for client meetings

→ Dress correctly

→ Finalize shot list

→ Finalize logistics

→ Book accommodation

→ Make travel arrangements

→ Agree copyright

→ Draw up license

→ Confirm timetable

→ Circulate brief

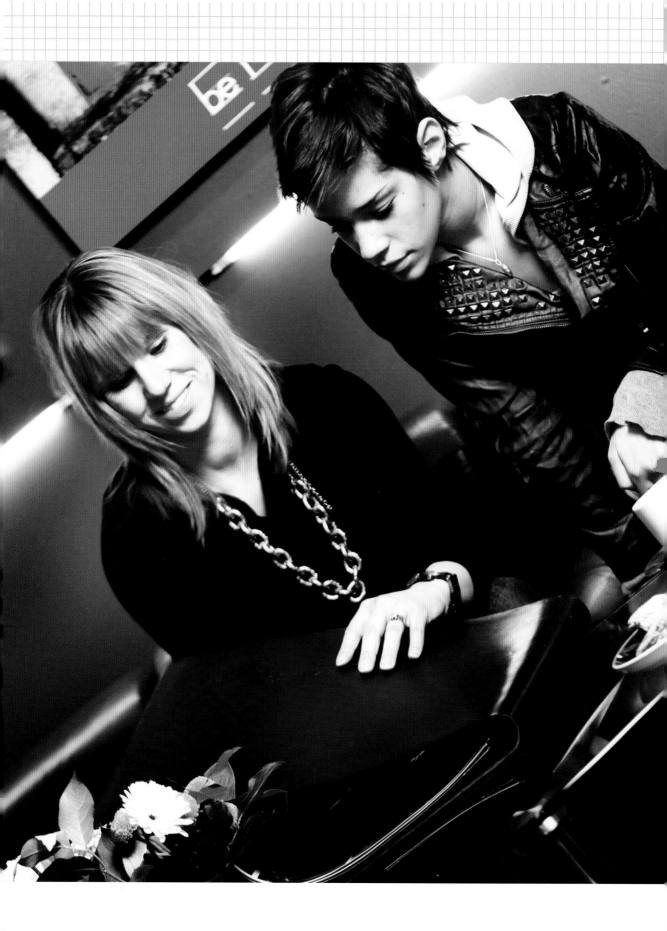

1.2

LIAISING WITH AGENCIES

→ CREATIVE AGENCIES AND WHAT THEY OFFER

→ WORKING WITH PHOTOGRAPHY AGENCIES

→ BOOKING MODELS

→ MODEL RELEASE FORMS

→ HOW TO USE THE BRIEF

CREATIVE AGENCIES AND WHAT THEY OFFER

Not all photographic commissions will come directly from the client. Bigger clients may prefer to hand their projects over to reputable creative agencies who will then commission you to take the photographs. This means you'll be dealing with the agency rather than the client.

The benefit of working with creative agencies can be the exposure of photographing for big-name brands. Having these photos in your portfolio can help open doors to other big-name commissions.

You may have to deal with a certain amount of "creative speak" (involving discussion of "brand identities" and so on) and possibly work with more people on shoots than you're used to, but they provide good experience and can be hugely rewarding—not to mention lucrative, as bigger brands also tend to have bigger budgets. It pays to do some background research on the agencies you're going to see; a bit of homework can go a long way.

Collaborating with creative agencies can lead you to all sorts of interesting projects—from editorial and advertising shoots, to providing photos for company brochures and marketing literature, as well as shots for websites and client's artistic illustrations. You will invariably shoot to a specific brief and according to the agency's "creative vision."

A positive aspect of working with agencies is that if you have any reservations about certain ideas or photographic styles, you can suggest improvements and alternatives for the agency without potentially offending the client directly. Although be sure to tread carefully and not step on anyone's toes.

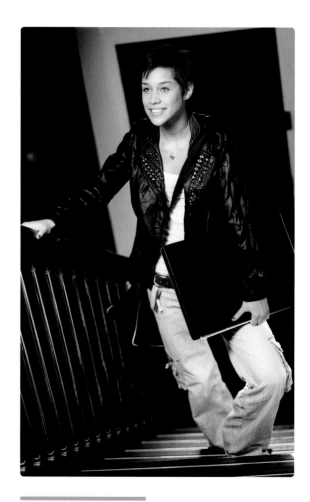

Above > Do your research on creative agencies before meeting them. A little preparation goes a long way and will help boost your confidence.

PRO TIP!

The added benefit of working with creative agencies is that if you do a good job they may well consider booking you for other assignments with other clients of theirs. So do your best to provide a professional service and make a good impression in all aspects of your work.

WORKING WITH PHOTOGRAPHY AGENCIES

Signing up with a photography agency can be a good way of attempting to secure more work. It will depend on your experience and their current pool of photographers and client base, as to what assignments they pass your way. For instance, they may offer you a mixture of news, editorial, and corporate photo-shoots.

The agency will obviously take a cut out of any clients' fees, so you'll be earning less (than if you were working directly with clients), but the aim is to get more consistent work so the cash flow becomes more constant than if you were working solo.

Selling your stock

Many photography agencies also double as image libraries, so they will be able to sell your images too. In fact, your impressive portfolio and back catalog of images may well have been the reason they welcomed you on board in the first place.

The main advantage of an agency selling your photos is that it frees up your time to continue taking more photos and earning more money. The disadvantage is that they take a cut of any money made from image sales—and that can be as much as 40–60 percent. While this may seem a large chunk to "lose," it's better to think more positively and commercially; if the agency hadn't sold your image(s) you wouldn't be earning anything at all.

Also, be warned that some agencies would rather sell your photos for peanuts than not sell them at all, so you need to choose agencies carefully if you want to make money without devaluing your photos.

Cheap business

Unfortunately, this is one of the downsides of digital photography. Some naive amateurs with budget DSLRs will accept a low fee because they're so eager to get their images published. This regrettable lack of foresight and competition has driven prices down to create a downward trend for professional photographers used to carving out a decent sideline by selling their stock to image libraries.

However, get set up with a good agency, and if your images sell steadily and for a good price, it can be a good revenue stream to have trickling away in the background while you get on with taking new photos.

CHECKLIST

→ Do your homework on the creative agency that's commissioned you.

→ Voice your opinions on shoots with creative agencies to help work toward the best possible results.

→ Sign up with photographic agencies.

→ Aim to get regular work.

→ Prepare and organize your back catalog of images for stock libraries to sell.

→ Sign up with reputable stock agencies.

→ Try not to devalue your images with stock libraries.

PRO TIP!

Although there are benefits of being a "specialist" photographer (such as a studio portrait photographer), try to avoid being pigeonholed by agencies as it could restrict the amount—and variation—of commissions and interest in your stock images.

← 22
→ 23

BOOKING MODELS

If your client has charged you with the task of booking a model for the photo-shoot, start by casting potential models that suit the brief and photographic style. Contact two or three model agencies and explain your requirements, schedule, and budget. The agencies will then email or post you details of models who are potentially suitable and available. Double-check costs as agencies can often add a cut on top of their quoted fees.

When you've identified potential models, the agencies will either email you a selection of photos from the selected models' portfolios, or alternatively, it may be possible to browse the models' online portfolios on the agency's website. Be aware that portfolios could be out of date, so it's good practice to double-check with the agency that the models haven't changed recently and that their portfolios are up to date.

Draw up a shortlist of three of your best choices and send them over to your client for their approval. Respect their decision—model selection can be very subjective—and book the model.

Model agencies

It's a good idea to build a relationship with model agencies as you'll find some are more professional than others. This can also be reflected in their models, who may be more reliable, adaptable, and experienced than those from other agencies. If you regularly use certain model agencies you may be able to negotiate discounted rates for booking multiple different models over a period of time.

Above and left > When searching for a model with a specific look for shoots, draw up a shortlist of suitable and available models from a trusted or reputable model agency—email three models' portfolios to your client if they've asked to make the final decision.

PRO TIP!

Try to choose a model agency in the same general location as the photo-shoot, otherwise you (or the client) will have to pay extra travel expenses for the model. This also removes the added problem of travel arrangements for the model or worrying that the model won't arrive on time due to transport difficulties.

MODEL RELEASE FORMS

It's good practice to get your subjects to sign a model release form on your photo-shoots. These forms are a legal release signed by the subject of the photos granting permission to publish the photos. The form can also agree to compensation being paid to the subject if, for instance, they are posing for you for free in which case you could offer 15 percent of any money you make from publishing the portraits.

Paperwork for the publisher

Whoever is publishing the portraits will require model release forms, as liability lies solely with the publisher. So it's important to get the model release forms not only because your clients will need the paperwork to publish your photos, but also because it will help you to sell your photos to whoever wishes to publish them.

For this reason, always carry model release forms on shoots as you never know when you'll need them. It's always better and easier to get models to sign your forms on the shoot, rather than trying to track them down and post copies back and forth while your client waits impatiently for the paperwork.

Right > If you're looking to build up your portrait photography portfolio, save money by asking new models to pose for free, with an agreement that they'll get a small percentage of any money you make if/when you sell the images.

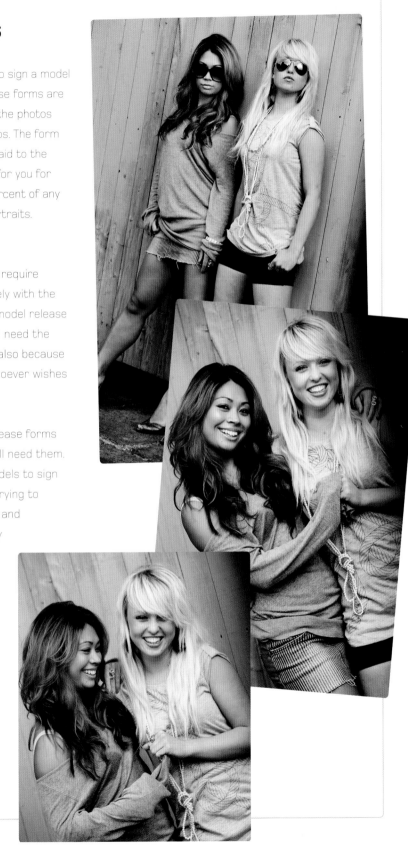

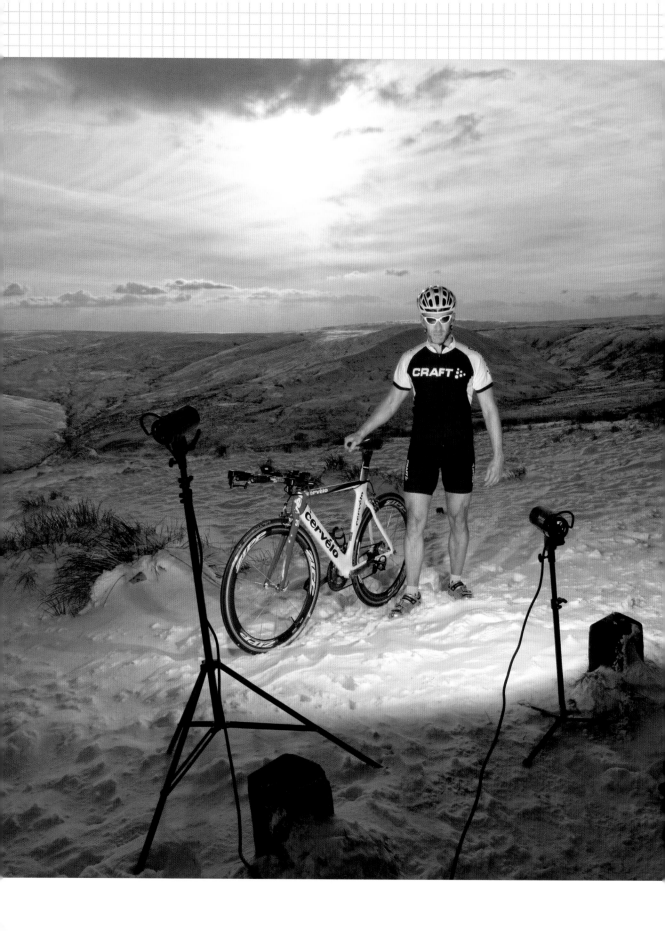

1.3

LOCATIONS

FINDING A LOCATION

Some photographers, art directors, and stylists find location hunting a chore. However, approached professionally, scouting for potential shoot locations can be both enjoyable and rewarding. Look at it this way, it's not often you'll get a chance to visit interesting cities and countries and still call it work!

Setting the scene

To find the location set in the brief, do some groundwork before traveling aimlessly to distant destinations. Have a good idea of locations to reconnoiter, and then plan a realistic choice of location visits into your day.

Local knowledge is priceless, so ask taxi drivers, tour guides, bartenders, and even the man on the street for advice if you can't find that elusive location.

It's best to visit places at the time when you'll actually be shooting, for example, if you're shooting an automotive advert with the car heading along a winding road and into the sunset, visit your potential locations when the sun is setting, that way you'll be able to picture the shot exactly.

Try to find a few different setup possibilities within walking distance of one location to save time on the day. Plus, of course, always take your camera—or at least a smaller DSLR or compact. This will allow you to get test shots of each location and start an image board that you can show the client, or keep on file for future shoots.

If you're pushed for time or stuck for ideas, consider hiring a reputable location scouting company to do the legwork for you. This can save the client the money they'd pay you to scout, and save you time by getting the scouting company to shortlist possible sites for you to check out.

PRO TIP!

Don't disregard unsuitable locations just because they're not right for the specific assignment you're scouting for. Look for the potential in all locations—you may find what's not ideal for today's shoot, may well be perfect for tomorrow's.

Far left > Be prepared to look close to home as well as overseas when hunting for suitable locations for shoots.

Top left > If you're in foreign territory don't be afraid to ask the locals for advice on photogenic locations—cab drivers can often offer more than a ride downtown.

Above > If your brief is for "a beautiful, early evening city scene" then make sure you view potential locations at the right time of day to see them in the best light.

Left > Sweeping cityscapes can be great for scenic shots as well as making a cool backdrop for contemporary lifestyle portraits.

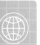

BOOKING VENUES AND GETTING PERMISSIONS

It's quite common for clients or agencies to book photographers to photograph certain subjects in a specified venue. These shoots can be exciting and enjoyable, as well as challenging, but before the shoot you'll need to gain access to the venue and get permission to take photographs there.

Booking procedures

Usually, the bigger and more popular the venue, the more red tape there will be to book the location—smaller venues may be more open to you "just turning up to take some photos." It will also depend on what you're photographing (people or products, for example), when you want to work, for how long, if you need the place to yourselves, and who you're working for.

If you're photographing a famous face for *Vogue* magazine and intend to spend all day there, the venue is more likely to charge (unless they can see the benefits of the publicity they'll get from the shoot), so you'll need to advise your client of these costs.

A quick phone call to the venue to get a contact name is the best way to start. Also have a look at the venue's website for their booking procedure and prices. However laborious, it's essential to follow the venue's procedures.

Seeking permission

Whether you're planning to photograph your subject at the venue, or the venue itself, and whether outside or inside the venue, you'll need permission. Contact the place directly by email or phone—to obtain a photographer's permit.

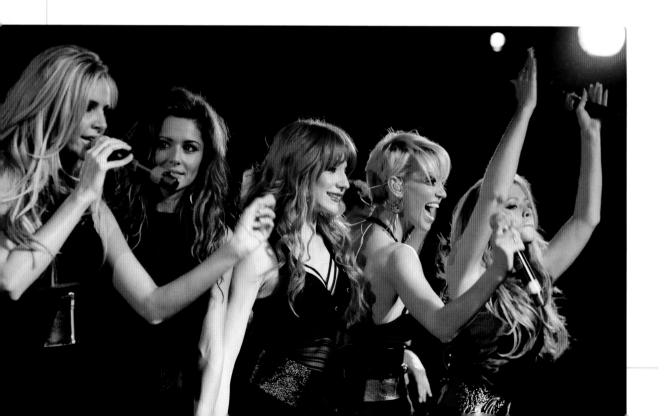

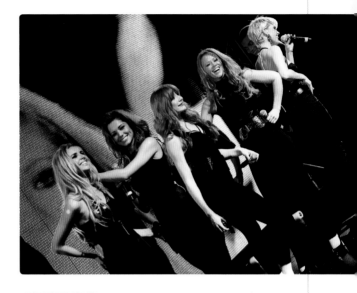

Always jot down the names and numbers of the people you've spoken to and the information they gave you. It's also better to keep a small notepad in your bag as phones and PDAs (and all your valuable contacts and information) can get stolen.

If you're photographing live performance events, many of the bigger venues won't give out photographer passes directly to photographers—especially if big-name performers are playing. This is because they want guaranteed coverage and publicity from any photos taken at their venue. If this is the case, to obtain a permit you'll need to be commissioned by a respected publication or client who can apply to the venue on your behalf before the event.

If you're working directly for the artist's record label, or for a sports team or racing team, they should be able to get a press pass for you.

PRO TIP!

There will be a limited number of photographer's passes for large music events and sports games, so they'll get booked-up well in advance. Plan up to eight to ten months in advance to avoid disappointment (or embarrassment if you've promised a client you'll be there to get their shots).

Far left > If you're seeking permission to photograph big names at big venues you're likely to need a commission from a magazine, newspaper, website, or record label before you apply.

Above > This shot of the band Girls Aloud was taken at a private performance, which helped with a sense of intimacy; but strict rules still applied governing when photos could be taken.

Left > You won't be allowed to use flash when photographing performers, so set a high ISO and use the stage lights to your advantage.

← 30
→ 31

DEALING WITH THE PUBLIC

It can prove challenging when working in public places with people in the vicinity of your setup or walking in front of the camera at inopportune moments.

The trick to dealing with the general public on photo-shoots is to always remember that they have as much right to be there as you. Just because you're a working photographer and have a deadline to hit, that doesn't give you the right to boss strangers about—in fact, only bad things will come from a bad attitude. Instead, relax, stop yourself from getting stressed by consciously reminding yourself not to rush to get the shot. Remain positive that you'll get your shots all in good time.

Professional politeness

People will be inquisitive if you have a big DSLR and big lens, even more so if you have lights set up. You're likely to also get the occasional trying questions: "What are you photographing?" ("That person behind you! Now if you'd just like to just step out of the way…") And if you're using a big DSLR on a tripod, people may get all excited and say things like: "What are you filming and who do you work for? Can I be on TV…? Hi Mom!"

You can't blame them for being interested. The life of a professional photographer is interesting to most people, so it's best to have fun with the public. Humor them, keep your cool, be patient, chat to them, but not too much, then politely ask them to step out of the way so you can carry on working and get your shot.

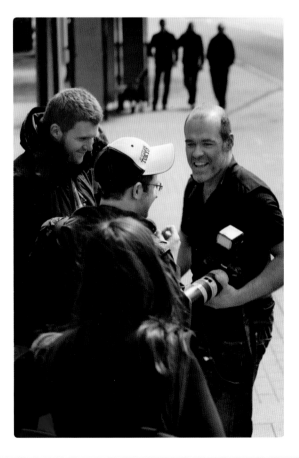

Left > Be polite, patient, and friendly with people when shooting in public places and they'll soon let you get back to work.

Right > The general public can sometimes make great subjects so embrace their inquisitive nature and bag yourself some top shots.

PRO TIP!

Of course the best way to deal with the public is to not have to deal with them at all. If possible, get on location early and get your shots before the bigger crowds arrive and start getting in the way. You'll also find early morning light will produce better images too.

WHAT TO TAKE

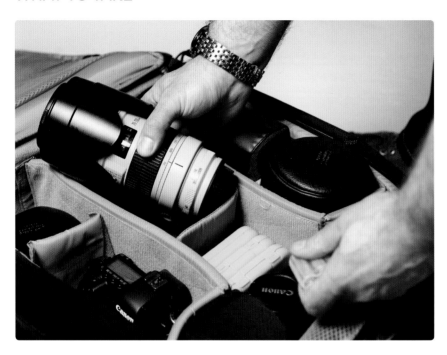

Left > Before packing the night before the shoot, double-check all your gear is in good working order, with batteries charged and memory cards empty and ready.

Bottom right > By adding your planned lighting setups and exposures on to your shot list, you'll save time on your shoot as well as ensuring nothing is missed out.

You may not be a list type of person—most photographers aren't, but their assistants usually are. A quick brainstorm and a written list of photo-shoot essentials will ensure you don't forget anything on the big day.

Learn to get into the habit of getting your kit ready the day before the shoot. Put your camera and flashgun batteries on charge, format your memory cards so they're empty, and pack twice as many memory cards as you think you'll need. Also remember to clear space on your portable hard drive or laptop as necessary.

Pack your camera bag so that you have the right camera bodies and lenses for the shoot, check your lights and radio triggers, and charge your cell phone and any portable battery packs. If you're working on location and shooting with models, take supplies such as a flask of coffee, blankets, and gloves.

Specialist kit

Think about the portrait style you're shooting and whether there are any props or photography kit you'll need to source. If you need to hire specialist equipment for a specific shoot—such as a specific high-spec, high-cost lens that you don't own—you'll need to clear these costs with the client first.

PRO TIP!

As a professional photographer you won't always know when and where your next meal will be—let alone if you'll get the chance to break for lunch or dinner at all. Eat well before a shoot—big, healthy breakfasts can keep you going all day. Avoid a rumbling stomach and dehydration by carrying food and water to keep you going during the shoot.

BEING PREPARED

If you fail to prepare, prepare to fail. Preparation is the key if you want shoots to go smoothly. Make any arrangements—such as booking a model or studio, sorting out flights or accommodation, hiring a car, or applying for press accreditation for a specific venue—as soon as you're commissioned, not the day before the shoot.

If you're shooting on location get directions, an address for your Sat Nav system, or go to Googlemaps.com and print off a map, so there's no chance of getting lost or arriving late. Work out your travel time and always aim to arrive on site early.

Pre-shoot tactics

For each photograph and setup, even experienced pros like to make a note of the camera, lens, exposure, and lighting combination they plan to use. For example: Canon EOS-1Ds Mk III DSLR body, EF 85mm f/1.2L lens, f/2.8 at 1/125 sec, and ISO 100 with two lights—an umbrella to the left, a soft box to the front, and a gold reflector to the right.

Clear weather, clear head

If you're shooting outdoors check the forecast the day before (any earlier will provide you with an inaccurate forecast), pack appropriately and prepare suitable clothing.

For location jobs on days with changeable weather, it will help to have access to a big car or van on shoot day, so you, your clients, models, stylist, and assistant can sit and stay dry in the car while waiting for the rain to pass.

If you plan for every eventuality you can relax knowing that you'll be able to confidently tackle any challenges the shoot brings. Make sure to get a good night's sleep and lay off the alcohol—hungover photographers and photo shoots do not mix well!

CHECKLIST

→ Find location

→ Book venue

→ Get permission to shoot

→ Be polite to the public

→ Book travel and accommodation a week before

→ Charge batteries and pack your kit the night before

→ Check weather forecast the night before

→ Print directions for location shoots

→ Arrive on location early

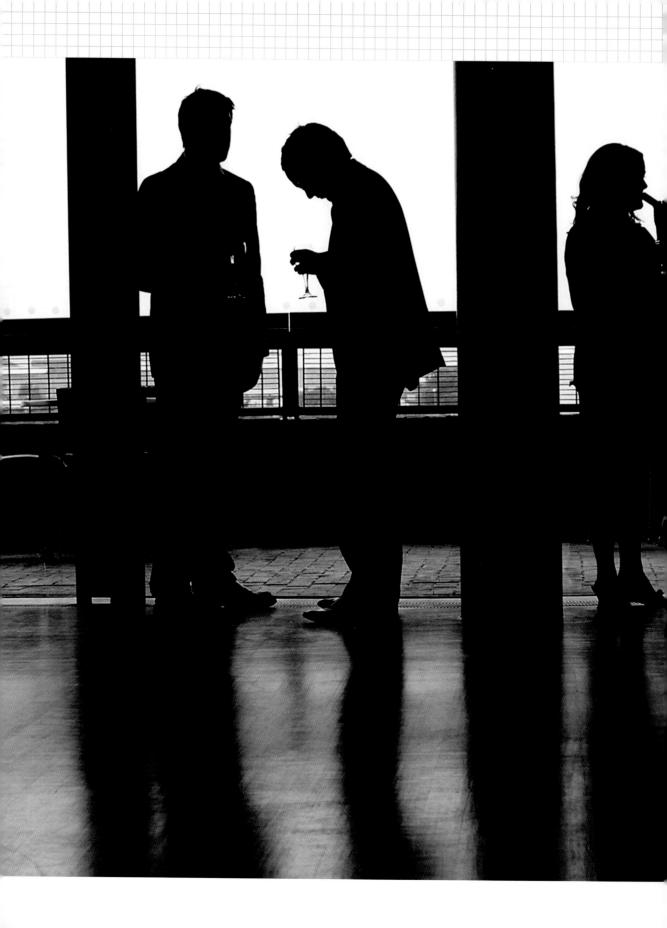

1.4

THEMES, PROPS
AND STYLISTS

→ IDENTIFYING THE THEME

→ SOURCING SETS AND PROPS

→ BRIEFING A STYLIST

← 36
→ 37

IDENTIFYING THE THEME

Choosing the artistic route of a photo-shoot is a big decision. Experience comes into its own in these situations, and after a while, you'll learn to quickly pick the right theme and photographic style to suit the subject and brief perfectly. However, there's always a first time when you'll need to select the best theme for a client.

To identify a suitable theme, find out where the photos will be appearing and who the target market or end user is; is it a product with an existing customer base of millions and are the photos for an international ad campaign, or simply a family portrait for mom and dad's wall?

Be smart, think carefully, and go with a theme that fits the subject best. Don't get clever and overcomplicate themes—for instance, don't pick an abstract theme for a big brand if they've always had bold and clear photography for their previous photographic campaigns.

If you receive a brief from a potential client, remember that they have come to you because of your unique, individual photographic style and the way that you can adapt this to fit the brief. Be bold, be brave, and push the boundaries.

Photographic style

Whatever your subject, the photographic style will have the biggest influence on your theme. It's all about creating the right feel and tone with your shots, and your lighting, color palette, props, and the subject's surroundings need to reflect this.

For this practical example, we've concentrated on a fashion shoot for the Love Miss Daisy vintage clothing company. We finished the shoot on location with this setup using only vintage petticoats draped around the model. The client completely trusted our vision and was overjoyed with the end results.

Shooting to a theme

The theme of the shoot was to show off various vintage dresses and outfits in a forest location. We wanted to finish the shoot by pushing the boundaries of the brief and to produce a striking cover image for the client's promotional material. Standing in a forest pond at 9:30pm isn't for everyone, but we made the shoot lots of fun and shot quickly. We chose to light the model from the front/right with a large Octa box. We also used two Elinchrom Ranger heads and a little touch of smoke to add some atmosphere to the rear.

Dramatically underexposing this shot turned a summer evening into night, giving the shot ultimate drama, and drawing the eye straight to the model and the clothing. Although our finished image deviated from the original traditional vintage theme, the client was happy with how our ideas grew organically throughout the day's shoot. Finishing with an image with such a strong look can open the door to many other types of shoots, so don't be afraid to experiment.

Left> Choosing a theme suitable for your client (and their subjects or products) is a critical stage of the photographic process.

Right> Although it's important to stay within the parameters of the brief, don't be afraid to push the boundaries—such as taking the products or models outside of the studio space for dramatic results.

PRO TIP!

Before you start shooting, think about what your shots need to say. Your photos are merely a way of visually communicating with people, so you need to ensure they're saying the right thing.

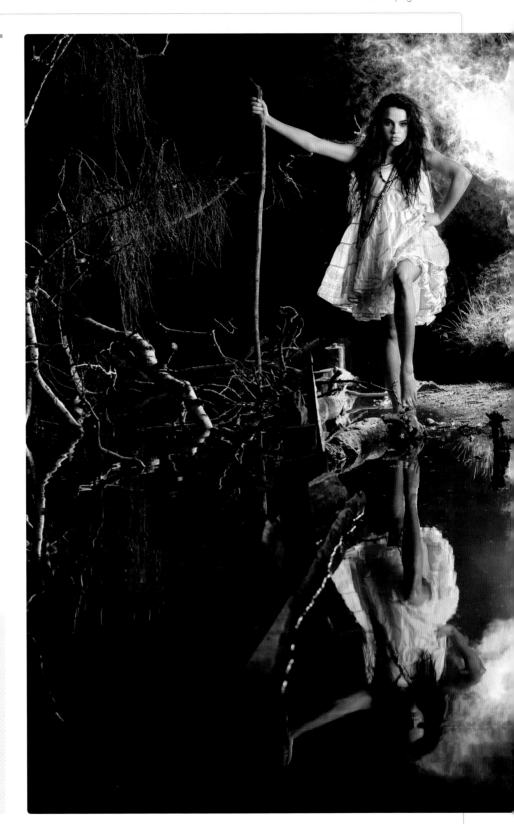

← 38
→ 39

SOURCING SETS AND PROPS

Locating a suitable set and tracking down props will take all of your initiative, especially if your client needs you to work to a strict budget and deadline. Think practically; choose a set that's easily accessible for everyone or every product, is big enough and suitable for your brief, and either has good places for natural light to reach your subject, or space to set up flash lights.

A set can be anything from a disused warehouse to a penthouse suite in a five-star hotel, from a back street to a hilltop. The type of set you use obviously depends on the theme and photographic style you're going for and your budget. Whatever your choice and costs, you'll need to get both these approved by the client before splashing out and settling in.

Finding props

Props can often be the missing ingredients that give your shots that special something, helping them to look more professional and detailed. Anything from a guitar in the background or designer jewelry around a model's neck, a flamboyant lampshade or candle holders can be considered a useful prop.

If you can see the potential in certain props, such as a weathered sofa, a dilapidated wooden table, or an ornate armchair, consider buying them as you may find you can get multiple use from them for future product, food, or people shoots.

Shop around and check out big department stores and local suppliers. Searching online can be a great way to track down obscure objects, and pricing will also be more competitive online—but the downside is you can't check the props in person to make sure they're right for the shoot.

Try taking props outside. Sometimes you can blow the brief wide open and give the client something they didn't expect by taking props out of the studio.

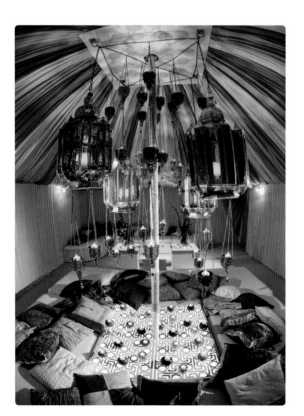

Left > It may be easier and cheaper to locate an exotic set already dressed for you rather than creating your own from scratch.

Right > Well-placed and well-chosen furniture can be the perfect prop to transform your shots and create a different mood.

PRO TIP!

If you're on a budget, scour thrift stores for props as it's surprising what good stuff other people are happy to discard. Also contact furniture brands, clothing designers, and product manufacturers directly to see if they'll supply what you need in return for some free publicity.

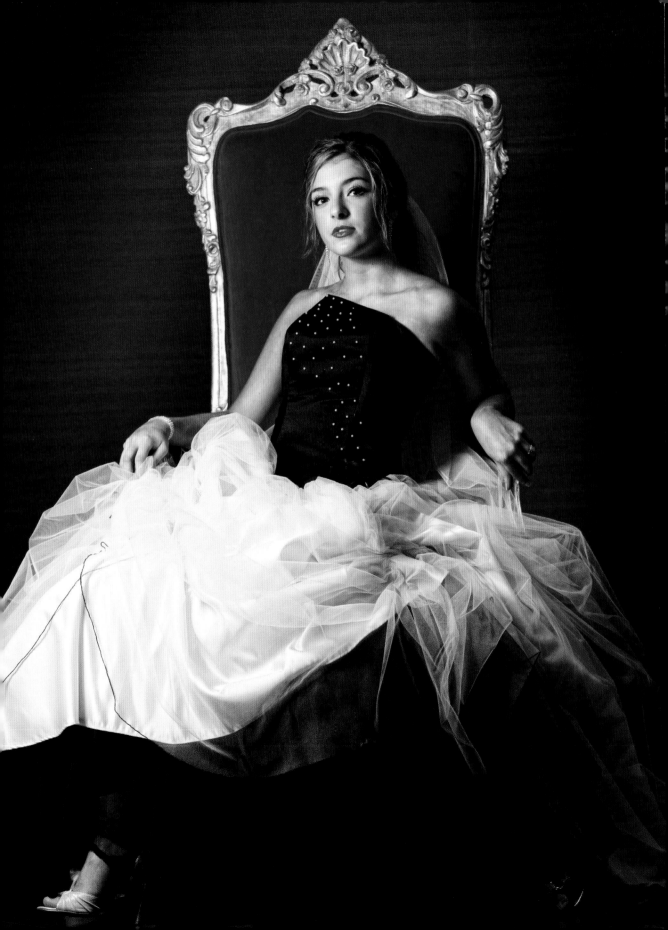

BRIEFING A STYLIST

On bigger shoots—with high-profile clients or brands—you may well get to work with stylists. They can be a great help as they can dress the set to establish the right tone for the shoot, as well as source and select the designer wardrobe when you're photographing people. Some stylists may also help source sets and props.

Your job is to give them a clear brief so they know the exact look you're going for. Provide concise instructions, and show the stylists visual examples of the look and style you want.

Experienced stylists may also have opinions on lighting; this can be a help as well as a hindrance, so it's up to you to whether you act on their advice or take control and set up the shoot your own way. However, don't annoy them—if you make it difficult they are unlikely to want to work with you again.

PRO TIP!

Don't forget the importance of good hair on a portrait shoot. Sometimes makeup artists will double-up and style the hair too, but double-check before the shoot because if your model's hair looks lackluster, so will your shots.

Briefing hair stylists and makeup artists

Good hair and makeup can transform your subjects, and can be the difference between bland shots and beautiful portraits. For the hair and makeup to look good, however, takes thorough instruction. Show hair and makeup artists printed examples or tear-sheets from magazines—or even shots on your camera or computer—of the sort of look you want. This will help avoid any confusion as describing makeup and hair styles can lead to misunderstandings—you don't want to end up with a dark gothic look for a summery beach shoot, for example.

Above > Good stylists are worth their weight in gold. Welcome their advice and assistance.

Top right > Although it may sometimes seem it's eating into valuable studio time, accept that hair and makeup will take time, as it's essential for preparing your subjects for professional portraits.

Right> Makeup artists need clear instructions for the look you want.

Be clear and to the point, explaining how long the artists have to prepare each model. New and inexperienced artists may work slowly, eating into valuable studio and shooting time. It won't hurt to ask them to speed up if they're behind schedule.

Be aware that everyday makeup that looks great on the street may not look so good under the scrutiny of studio lights; if it appears shiny and reflective when photographed, apply extra matt foundation.

Always check the makeup. Do the eyebrows or lips need more definition? Do the eyes need more eyeliner or less mascara? Could the cheeks do with a little blusher? Get it right before shooting to avoid wasting shots and valuable time.

CHECKLIST

→ Identify the theme
→ Choose the photographic style
→ Push the boundaries of the brief
→ Source the set
→ Source the props
→ Dress the set
→ Brief the stylist
→ Brief the makeup artist
→ Don't forget the hair

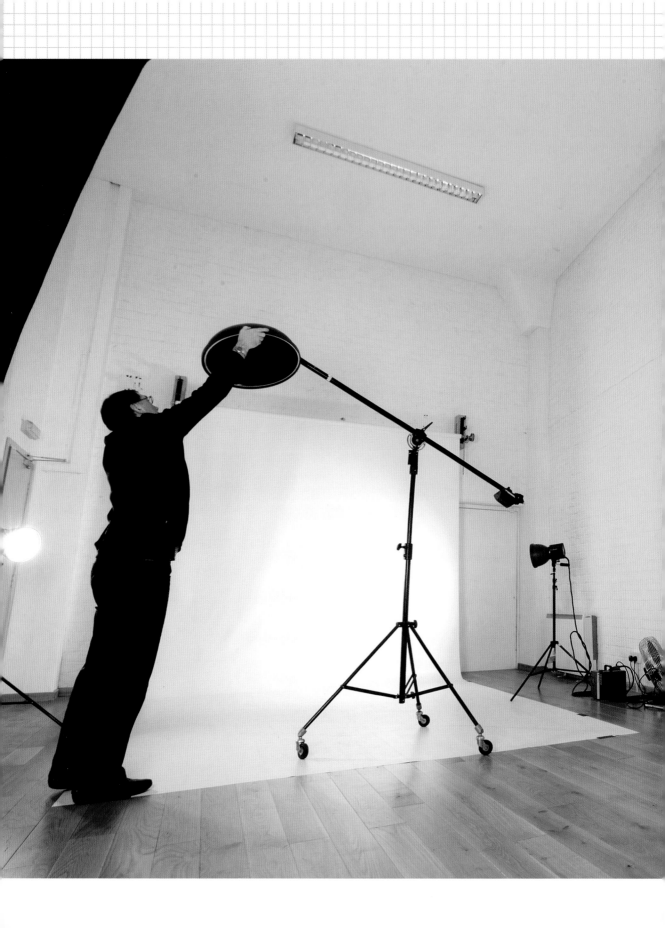

1.5

STUDIOS

← 44
→ 45

WHAT TO LOOK FOR IN A STUDIO

A first-rate studio will go a long way to making your photo-shoots run smoothly and successfully. The benefit of shooting in a studio is that you're in complete control of the space, your subject, and the lighting. But it's not just the size—or the coffee-making facilities—that you should consider when choosing a studio.

Location and parking

Is your studio easy to find? You don't want clients getting lost or models always arriving late simply because they couldn't find it. If in a busy, city-center location, do you have reserved parking spaces? It's best if people don't have to park three blocks away. and that it's in a safe and secure area.

Is there a separate, partitioned office that you can use? It can be far more productive to have a base away from home where you can work. And is there more than one studio in the unit? If so, what types of photographers use the other spaces? It could make for an interesting (read: embarrassing)

situation for you if you're photographing businessmen while there's a nude glamor shoot underway next door.

Is big better?

The size of your studio will be governed by your subjects and budget. Unless you have regular assignments (and therefore the regular revenue) to photograph cars, you won't need—or be able to afford—a tennis court-sized studio. That said, while a 30 x 30-foot (10 x 10-meter) studio can appear very big when empty, it will appear very small when your lights, backdrops, and subjects are set up. A claustrophobic studio does not make for a conducive working environment, whatever you're photographing.

Pick a studio that's big enough for your needs, bearing in mind that low ceiling heights could cause problems when setting up lights, backdrops, or when shooting down to your subjects from a ladder. Some studios have retractable ceilings, or are set on two floors, with a balcony to shoot down to the first floor, but this might not be necessary for your shoots.

Left > Working in a studio space enables you to take full control of your environment and lighting to ensure professional results.

Right > Choose a studio with space to shoot while also allowing enough room for lights and diffusers, reflectors and backdrops.

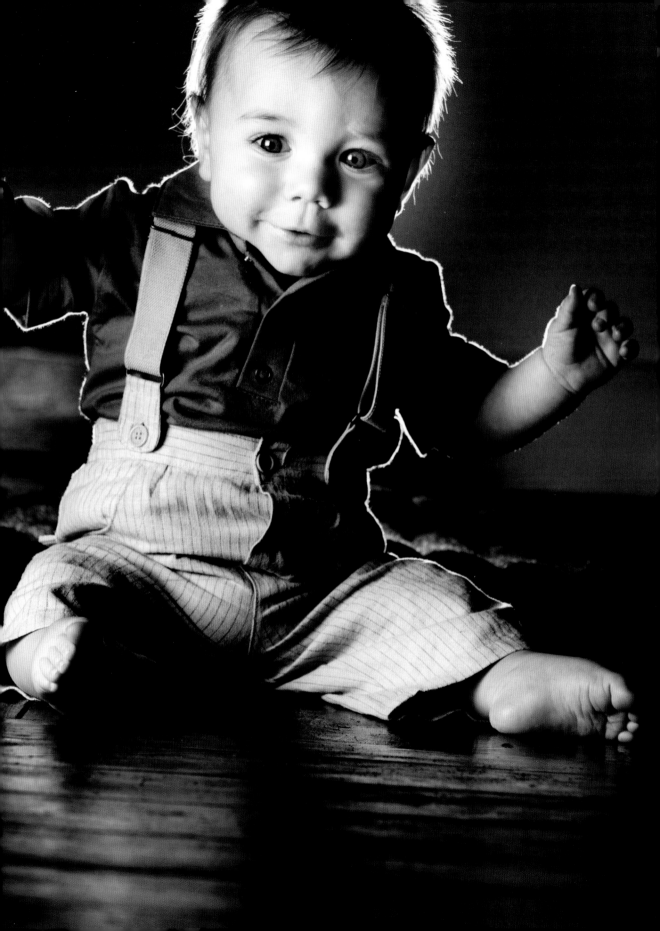

SETTING UP A HOME STUDIO

If you're just starting a career in photography, or are a semi-pro working with a small budget, then a home studio could be the best all-round solution.

A photo studio at home doesn't mean an unprofessional setup or unprofessional results. In fact, put together and handled correctly, you'll have full control over your studio space and lighting, which should mean better image results for you and your clients.

Shooting space

You don't necessarily need the biggest room in the house or a room with tall ceilings to set up a successful home studio. You just need enough space to set up a backdrop on two stands—high enough so you can shoot people standing up—with room for lights on either side. Better still if there's also room for lights behind the backdrop, and room for you and a light in front of your subject.

In terms of what color to paint the studio, white walls are always best as you'll be able to bounce (and therefore diffuse) light off the walls, as well as using the walls as backdrops.

If you're only shooting products that generally fit on a table top, then make the most of that small bedroom that's currently full of junk. Use an old table and run a half-roll of paper down on to the table top, add two or three lighting heads with soft boxes on either side, and you're all set.

Above > **Consider converting your garage or building an extension in the yard to use as a photo studio—you can even choose to do evening shoots if you want!**

Left > **Home studios will save you money in the long run, and if you decide to move house and sell up, it will also add value to your property.**

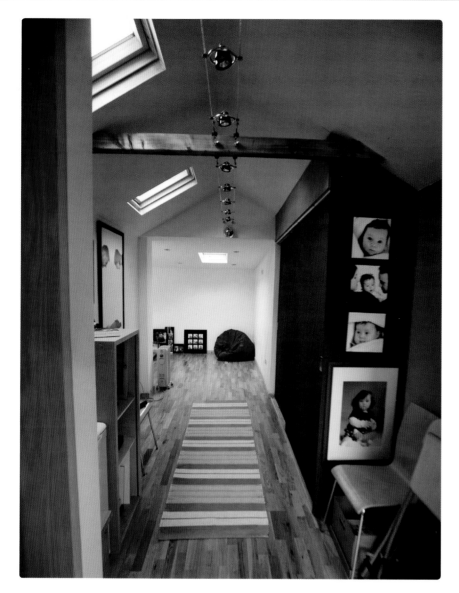

Left > Spend time making your home studio as professional as possible so clients know you mean business. Adding skylights will brighten the place up too.

Above > All you need is room for a desktop and a backdrop to shoot against, with space for two lights on either side.

Top > It's possible to achieve professional results from a modest home studio with a basic lighting setup and simple backgrounds.

Convert your garage

If you've got a garage and it's only full of boxes of junk, then why not utilize the space to set up a studio. Some drywall and a lick of paint can work wonders. Fit an electric fan heater/air-conditioning unit, and a few electrical points, and you'll be good to go. If you're not entirely confident with your own DIY abilities, particularly where electricity is concerned, it may be safer to get the work done professionally.

PRO TIP!

With the right lighting setup you can make the most of any space in your home. If you have large windows, use them to provide a soft natural (non-direct) light, then use flash lights to add fill light to the shadowed areas on your subject.

BOOKING STUDIO SPACE

As well as choosing a studio that's in the right location for you and your clients, has accessible parking, and is within your budget, there are a few other factors to consider when booking studio space.

Does the studio provide lighting, with soft boxes, snoots, and umbrellas, as well backdrops—or will you need to bring your own? Are there any exposed walls, doors, or ceilings, and any props such as stools, a table and chairs, sofas, and stairs for you to use in your shots? What about free wireless broadband internet access?

If you only need the studio for 3–4 hours, ask if you can book a half day to save yourself (and potentially the client) money. You're more likely to get deals if you use a studio regularly. With this in mind, it's a good idea to build up a good relationship with local photo-studios, as you may be able to negotiate a discount for bulk bookings.

Spaced out

At the risk of stating the obvious, always double-check the studio you've booked is big enough for you and your subjects. Studios are measured in square feet or meters. It goes without saying, but if you're shooting family portraits you'll need a large space. Access for big products is also an important point to consider. If you're photographing motorcars/motorbikes, you'll need ground floor, or elevator/ramp access to drive/ride the vehicles into place.

Conversely, there's no point hiring and paying for a huge studio if you're only going to use a small corner of the available space.

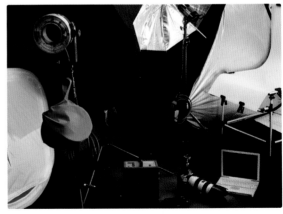

Left > When looking at studios, check out the walls to see if they have potential to work as backdrops for some contemporary portraiture.

Above > When booking studio space, double-check what lighting equipment will be provided and what gear you'll need to bring.

BUYING YOUR OWN STUDIO

Depending on your budget and frequency of commissions, consider investing in your own studio. It should pay its way over a few years and means you won't struggle to find and pay for a rented studio for every project.

Think about investing in a studio with other photographers you've worked with, or consider renting out part of your space to help pay for the space. By clubbing together you can spread the costs between you. Access can be arranged on a shared and booking basis. This approach works very well if you're on a budget or just starting out. Either way, with your own studio, you won't have problems finding a studio again.

Off the wall

It's best to pick a studio with neutral colored walls and ceilings. Most will have white walls and ceilings, but watch out for studios with different colored walls as you can't bounce flash or lights off them—it will create color casts on your subjects—which means you'll need to invest in and constantly reposition moveable, white partition walls.

Depending on what studio photos you're taking, a mixture of wall colors or textures can be good; a bare brick wall, for example, can make for good, gritty, urban portraits.

Cheap Colorama rolls are also available for backgrounds in a variety of colors. These are long paper rolls that you can use, cut off, and keep using, and are a space-efficient way of getting very cool, funky colored backgrounds.

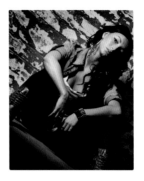

Left > Photographing people can be challenging, but if you're shooting in your own studio, you'll feel more in control of the site and final results.

Up to date

See if your potential studio has been recently decorated, and check that there are plenty of electricity points for your lights, computer, and kettle, and ensure broadband internet and phone lines are installed. If they aren't, factor these installation costs into the price.

Finally, is there running water, a bathroom and washroom, and perhaps most important of all, a fridge, sink, and/or coffee machine?

CHECKLIST

→ Studio location and parking
→ Studio size and space
→ Separate partitioned office space
→ Will you be sharing the studio?
→ Consider setting up a home studio
→ Or hire studio space
→ Or invest in your own photo studio

PRO TIP!

When scouting out studios to buy, check there's working heating or air-conditioning. The only thing worse than a freezing cold studio is a roasting hot one.

SECTION 2
PHOTO-SHOOTS

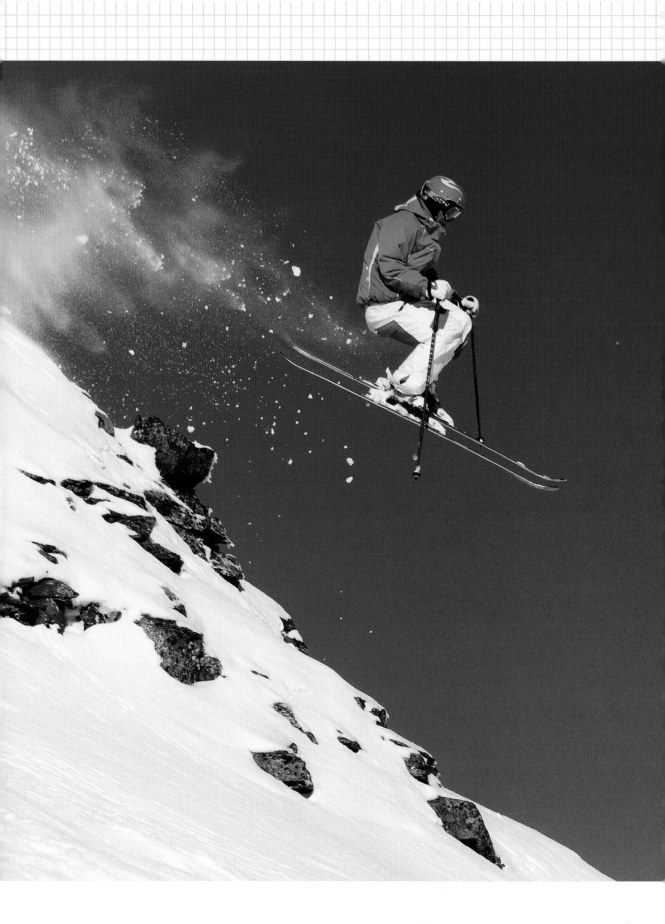

2.1

THEMES, PROPS, AND STYLISTS

→ PHOTOGRAPHING FOOD

→ PHOTOGRAPHING PEOPLE

→ PHOTOGRAPHING PRODUCTS

→ PHOTOGRAPHING INTERIORS AND GARDENS

→ PHOTOGRAPHING ACTION

PHOTOGRAPHING FOOD

It goes without saying that food photography should always make the dish or product appear mouth-wateringly tasty. How you achieve this will be down to your client's brief, the shot list, and how the shots will be used, whether as life-style editorial features, for a glossy cookbook, or for large, striking adverts.

Hot and steamy

When photographing food, it's essential that the food appears ready to eat and exactly as the client desires. So, for example, if it's an advert for a jar of Italian tomato sauce, then you'll want the pasta and sauce freshly cooked, served up hot and steaming, with a sprinkling of parmesan cheese, perhaps a sprig of basil, and a glass of red wine in the background.

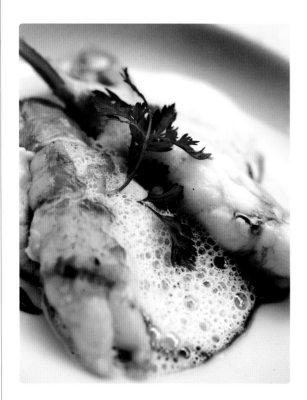

Left > Be considerate of the chef's needs and be ready to work around food preparation and cooking times.

Below left > When it comes to food photography, if it looks tasty and good enough to eat, then you're doing your job right.

Right > Fill the frame with the food by using a macro lens to get close and to show every detail and texture in the cuisine.

Head chef

On these shoots you need to be sympathetic, both to the client's needs and the chef's preparation and cooking schedule. Both the chef and the client will, no doubt, have suggestions about how the dish should look. If there's a stylist there, consider his or her suggestions too. But bear in mind that these are only suggestions; as the photographer, it's up to you to take everything on board and then make informed decisions to achieve the best images. As the old saying goes, too many cooks spoil the broth—and too many cooks can also spoil the photographs!

Don't be afraid to take charge and politely—but firmly—say that you'd like to set up a shot in a specific way, explaining why it will produce better results. After all, it's the common goal for everybody on the shoot, and it's your neck on the line if the final photos aren't up to scratch.

PRO TIP!

The current trend for food photography is to keep it looking natural—so that means using natural light for your shoots, whether light from a window, if shooting indoors, or taking the food outside to shoot in the yard where there's some shade.

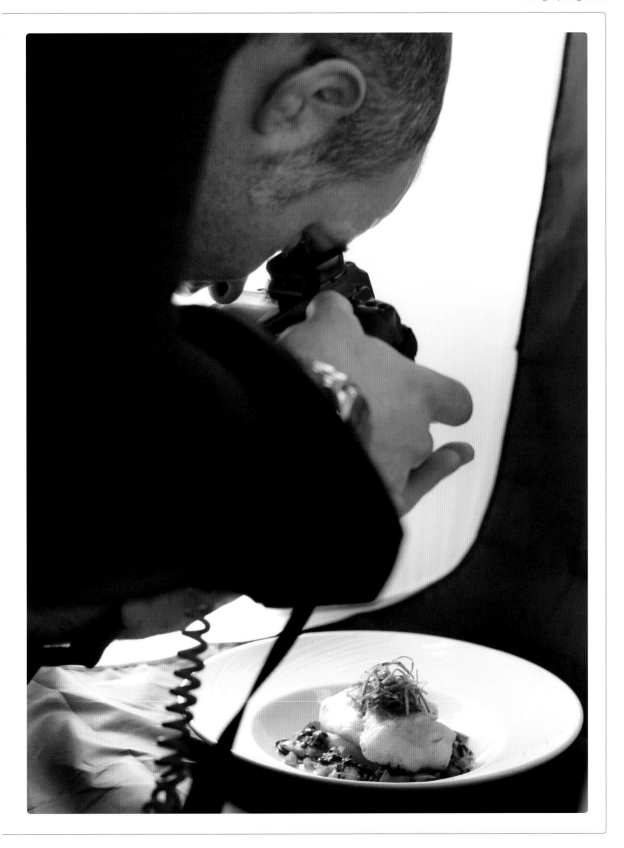

PHOTOGRAPHING PEOPLE

The recipe for great portrait shots is made up of two simple, yet key, ingredients—good rapport and good lighting. Both are essential if you want to take successful portraits.

Without a good rapport with your subjects, they won't engage with you and your camera, and that means lifeless portraits. Without good lighting you'll be left with a set of unattractive snaps any amateur could have taken. We'll look in more detail at lighting setups in Chapter 2.3, but for now we'll look at the main strategies for taking striking portraits.

Good rapport

If you aren't able to connect, or at least, communicate with your subjects, you will struggle to get decent results on camera. It's often true that you get from your subjects what you give to them. You don't need to be overly charming, you just need to be sociable and welcoming.

Meet with your client beforehand and have a coffee and an informal chat. Start off by getting to know them, building up slowly and naturally to talking about portraits. Do this in a professional but friendly way. Ask what style of portrait they like and show them your portfolio for inspiration and ideas.

Professional approach

With the portrait style established, emphasize the fun aspect of portraiture. If you think it's appropriate, put on the radio or music to suit the mood. As you're shooting, be complementary and tell your subject how photogenic they are.

Be confident when shooting and move around to get different angles. Keep providing clear directions, feedback, and encouragement. Within reason, maintain a sense of fun when you're taking photos and regularly show your subject your shots on your DSLR's LCD or on the computer screen if you're shooting tethered. By seeing their portraits it shows people that they look good on camera, and gives them confidence for the next round of shots.

If, in the first ten minutes or so, you don't feel the portraits are working particularly well, don't be disheartened. Once your subject gets used to being in front of the camera, they'll eventually relax; this will show in their face and expression.

Right > Successful portraits aren't all about people looking directly at the camera. Be creative with suggestions on how they should pose, which direction to look, and how you position them in the frame.

PRO TIP!

Start a scrapbook or pin board in your office with tear sheets from magazines with photos, adverts, or editorial features that you particularly like and would like to recreate in your own shoots. If you're a photographer, these are helpful to show clients—if you don't already have the same sort of shots in your portfolio—who might need guidance to pin down the style of photos they're after. And if you're an art editor, model, or stylist, you can show photographers the style of photo you're looking for.

PHOTOGRAPHING PRODUCTS

Although inanimate objects don't move about or complain, that doesn't mean that product photography is easy. Shooting objects and products requires careful planning and good photographic technique.

The trick to photographing objects successfully is in making the seemingly uninteresting, appear interesting. For instance, a straightforward photo of a black hi-fi can look incredibly dull if not handled or approached correctly. That doesn't mean you always need to try and bring every object to life in your photos—unless that's what the client wants—but it does mean you'll need to produce professional results every time.

Product placement

When you're shooting products, your client will want you to photograph their products in—literally—the best possible light. Whether it's merchandise that you're photographing for a magazine feature or review, or a product for a dedicated advertisement, and no matter how large or small the product, the client will want you to produce attractive shots. It's up to you to make this happen by using the right lighting and creative composition.

PRO TIP!

Aim to get your shots as good as possible in camera. This will save time in the post-production stage. Although when processing and editing your images, you will be able to boost, lighten, and darken specific areas to ensure the products stand out in the image.

Below > **Product photography brings static objects to life. Use artistic lighting and dramatic compositions to bring dynamism to your images.**

PHOTOGRAPHING INTERIORS AND GARDENS

Left > When photographing office interiors, use any glass and reflections or doorways to add depth to your shots.

If photographing food and products is all about making them appear tasty and attractive, photographing interiors and gardens is all about ensuring the location looks beautiful and inviting.

Interiors

When photographing the interiors of houses, apartments, or offices, while you will need to rely, in part, on natural light coming in through the windows, you can be in total control over the indoor light source by using the available built-in lights and your flash lighting heads. Use ceiling lights sparingly and instead use table lamps and standalone lights to create atmosphere. For flash lighting heads, position them creatively—in the top and bottom corners of the room, for instance—to light the important parts of the space.

Gardens

For garden photography you will need to be patient as you will be working with nature and the elements. This means being flexible, working around the weather, and waiting for the optimum light conditions.

The best and most colorful light for photographing gardens is at sunrise and an hour or so after, and an hour or so before and during sunset This is because the sun is lower in the sky, resulting in softer, more attractive and colorful light, and it also creates longer shadows which help to add atmosphere and depth to your shots.

Remember also that gardens "peak" at different times of the year. Although spring is generally the best season, it depends on the plants and the location of the garden. You may need to make repeated visits when certain plants have flowered to capture them at their best.

PRO TIP!

Learn to plan a year in advance with garden photography. Clients and publications work and plan months ahead and will be after seasonal photos well before the season actually starts. Learn to photograph gardens in winter, spring, summer, and fall, with a view to using and selling them the following year.

PHOTOGRAPHING ACTION

Action photography and action photo-shoots need to be approached in an entirely different way when compared with the preceding four photography subjects. The good news is that action photography gives you a chance to really flex your creative muscles.

Moving targets

The main difference with action shoots is that your subject (or subjects) will be moving. Depending on your client's taste, the location, and lighting conditions, shooting action essentially gives you a choice of two distinct photographic styles—freezing the movement or capturing a sense of movement.

Whether you're photographing children playing outdoors, or a live sporting or performance event, it's up to you to use and then capture the energy and emotion in your shots.

Photographer passes

If you're shooting at live performance or sporting events, you will need to seek permission and permits to take photos. This requires good advance planning, and the bigger the names or games, the more competition there will be for photographer passes.

If you get a pass for a sporting event, such as a soccer or baseball game, you'll be allocated a specific spot at the side of the field, and movement is likely to be restricted during the game so you don't obscure the view for fans, TV cameras, or other photographers. Bear in mind when photographing bands on stage, you are usually allowed to photograph the performers during their first three songs only. For both subjects, you will have to manage without using any flash.

Left > By using your on-camera flashgun you'll be able to move freely as well as freeze the action, but bear in mind it's unlikely you'll be able to use flash at indoor events.

Right > Well-positioned lights, a long exposure, and motion blur capture a sense of movement.

PRO TIP!

Making mistakes is all part of learning and improving. Don't be discouraged when things don't go according to plan. The mark of a true professional is how you handle and resolve the problems quickly and still produce high-quality results.

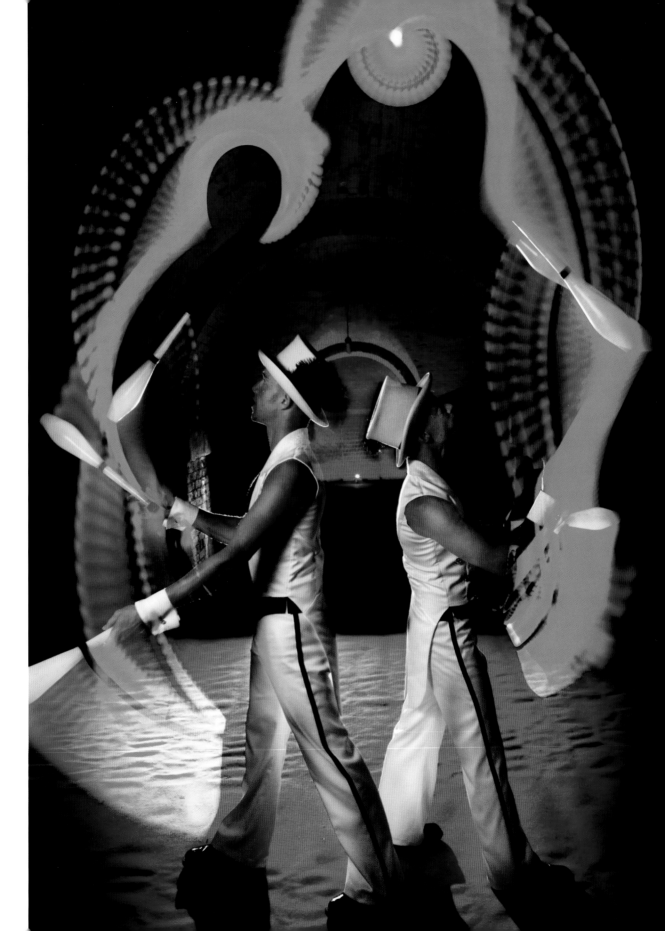

2.2

HOW TO SHOOT
LIKE A PRO

→ EXPOSURE ADVICE

→ FOCUSING

→ SHOOTING HANDHELD AND WITH A TRIPOD

→ SHOOTING WITH LIGHTS

→ HIGH ISO

→ WHITE BALANCE AND IMAGE QUALITY

→ USING HISTOGRAMS

→ USING LIVE VIEW

← 64
→ 65

EXPOSURE ADVICE

All photographers—from inexperienced amateurs to experienced pros—need a refresher course now and again on the best way to capture accurate exposures every time—whatever the conditions, whatever the subject.

The best way to master exposure is to stop using semi-auto shooting modes, such as Aperture Priority and Shutter Priority. Learn to shoot in Manual mode so you have full control over both aperture and shutter speed, rather than relying on your camera to set what it thinks is a correctly exposed shot. When shooting, try predicting the exposure, then get your camera out and see how far off or how accurate you are.

Refresh your knowledge

To explain exposure fully, let's briefly go back to basics. An exposure is made up of a combination of aperture and shutter speed (and ISO, but more on that later).

Wider apertures (such as f/2.8 or f/4) let more light onto your DSLR's sensor, while with narrower apertures (such as f/16 or f/22) less light reaches the sensor. The aperture you set also controls depth of field. Use a narrow aperture to maximize depth of field so more of your subject and scene is in focus—ideal for products, gardens, and interiors. Use a wide aperture for a shallower depth of field so only your subject is in focus and its foreground and background are out of focus—ideal for striking portraits, action, and food photography.

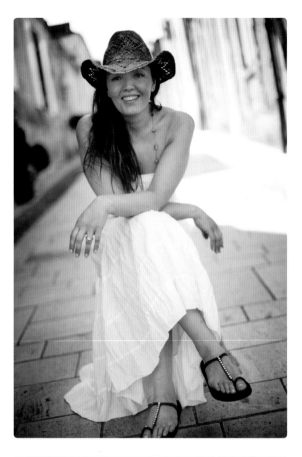

Light and dark

Adjusting the shutter speed controls how long your exposure will be by dictating how long the light falls on your DSLR's sensor. To brighten your shots, set a slower shutter speed to increase the amount of time the light hits your sensor, or increase the power of your flash lights if you're using them, or increase your ISO. To darken your shots, use a faster shutter speed to decrease the amount of time the light hits your sensor, or decrease the power of your lights, or lower your ISO setting.

In Manual mode you can still refer to the Standard Exposure Index—a scale that you can see when looking through your viewfinder or on your LCD panel—to set your shutter speed and aperture for a "correct" exposure, usually by setting the pointer on "0." However, it's best if you learn to take test shots then increase/decrease your shutter speed until your shots look as bright or as dark as you want them.

Farthest left > **When shooting indoors with bright subjects, your DSLR may underexpose the shot, so increase your shutter speed to let more light on to your subjects.**

Far left > **Use a wide aperture for a shallow depth of field to make your subjects stand out.**

Top left > **Set your exposure for your subject, not their surroundings, especially when shooting outdoors in mixed lighting conditions.**

Left > **Many photographers use semi-auto modes, but in Manual mode you control both aperture and shutter speed.**

← 66
→ 67

FOCUSING

Professional photographers need to be able to focus quickly and accurately to ensure their subjects are sharp every time, as clients won't be happy to pay for out-of-focus photos.

The skill with focusing is knowing which are the important elements to focus on, depending on your subject matter. This will help draw people's eyes to the key aspects of your images. For example, for portraits it's best to focus on the eyes, for product shots focus on the logos, and for food, focus on the item of food closest to you in the frame.

Although your DSLR gives you a big choice of AF (autofocus) points, most pros find the quickest way to work is to use the central AF point to lock the focus on their subjects, holding down the shutter button while they recompose before taking the shot.

Depth of focusing

Bear in mind the depth of focus will be affected by your aperture choice and resulting depth of field. For example, if you're shooting at f/2.8 with a focal length of 200mm when shooting portraits and you focus on your subject's nose, their eyes are unlikely to appear sharp in your shot. So make sure your focusing is exactly on their eyes—or shoot at f/5.6 so both the nose and eyes will be in focus when focusing on the face.

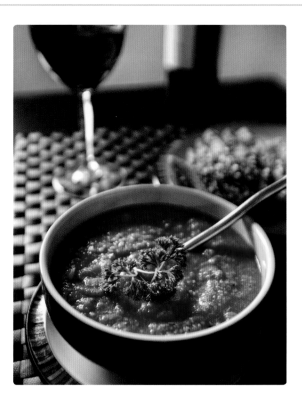

Manual focusing

Autofocus (AF) on DSLRs has become very accurate and more reliable these days, however there is still a time and place for manual focus (MF) as it enables you to fully control what's in focus in your frame. A good example is when shooting fast motorsports and your AF may not be able to keep up with the action. Switch to MF and pre-focus on the spot you know the subject is going to drive past, then take several shots on the burst before, during, and after the subject hits the spot.

Above > Selectively focusing on individual elements within your scene will draw emphasis to the main product or subject.

Left > Although autofocus on modern DSLRs has improved and is generally very accurate, in certain circumstances it's better to manually focus to guarantee really sharp results.

PRO TIP!

There are benefits to shooting using the different AF points—rather than the central AF point and recomposing—as they enable you to position your subject, product, or focal point of the scene according to the rule of thirds for better composition.

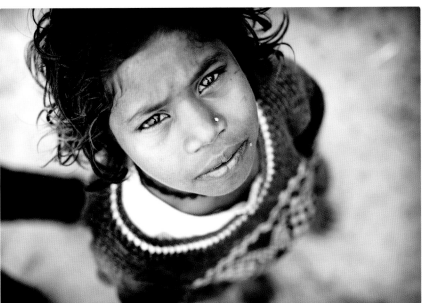

Above > When shooting with a wide aperture and long telephoto focal length (such as our example: f/5.6 at 200mm) the depth of field will be very small, so you'll need pinpoint accuracy with your focusing.

Left > When working with a wide aperture and mid-range focal length (such as our example: f/3.5 at 50mm) the depth of field will be slightly wider, making it more suitable for focusing on people's faces, while still blurring the background.

SHOOTING HANDHELD AND WITH A TRIPOD

For the majority of photo-shoots, most pros prefer to shoot handheld. Photographing this way allows you to work faster and offers you greater freedom of movement around your subjects to obtain better and more creative compositions.

If you're shooting handheld and using flash, the light(s) will help to ensure your shots are sharp. However, when shooting handheld without lights you'll need to make sure your shutter speed is fast enough for sharp shots.

It's important to remember the relationship between your lens' focal length and shutter speed: the longer the focal length, the faster the shutter speed will need to be, as any slight camera movement may result in blurred images. For example, if you're using a focal length of 200mm, make sure your shutter speed is at least 1/200 sec to ensure sharp shots. You may need to increase your ISO accordingly in order to set sufficiently fast shutter speeds when working in low light conditions.

Three-legged assistant

As well as supporting your camera to keep it rock-steady for sharp photos when shooting without lights, tripods can also make excellent assistants. When shooting in studios with lights, it's a good idea to use a sturdy tripod to take the weight of your hefty DSLR and telephoto zoom lens. This will leave your hands free so that you can jump in and reposition your subjects or objects, or adjust and move lights while your camera remains in exactly the right place.

Once you've focused on your subjects, using a tripod also enables you to look over your camera so that you can maintain eye contact with your subjects. Building this bond makes for a much better environment, as it's then more about you and your subject working together.

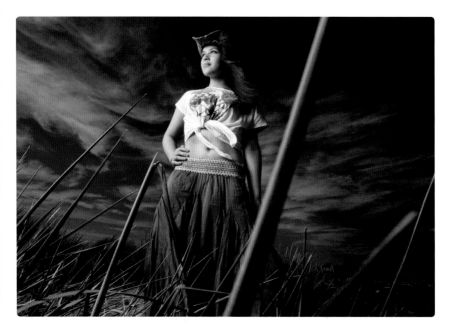

Left > Working handheld is faster and gives you far greater freedom for capturing more interesting and dynamic compositions.

Top right > When shooting outdoors in low-light conditions, it's essential you shoot using a tripod as your exposure will be too long to shoot handheld—even when shooting with lights.

Right > Using a tripod when photographing portraits allows you to keep your DSLR in position and focused while directing and connecting with your subjects for better poses and results.

Far right > If you prefer to work handheld but still want to use flash, then attach your on-camera flashgun and light your subjects creatively that way instead.

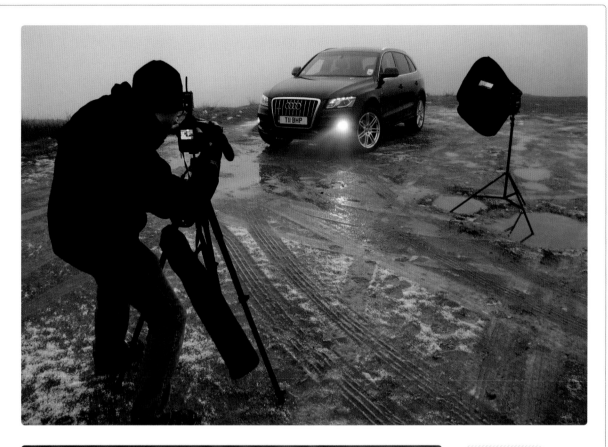

PRO TIP!

Tripods are also essential when shooting gardens in low light at sunrise or sunset, or interiors when you're only using the available light, as your resulting shutter speeds will be far too slow to shoot handheld without camera-shake becoming a problem.

← 70
→ 71

SHOOTING WITH LIGHTS

As a professional photographer, you'll need to be able to shoot quickly and confidently with lights in a variety of locations, whether you're photographing people, products, or interiors. The benefit of this is that you're in complete control of the lighting. You set the power of the light source(s), decide how many flash heads, and set their direction and positioning. Using lights means you don't need to worry about the sun, its position, or if it's night-time.

It's best to shoot in Manual mode to take full control of the camera and your exposures. Start off with a shutter speed of around 1/200 sec (bearing in mind your DSLR's top sync speed for shooting with lights) at middle aperture of around f/9. To brighten or darken your shots, instead of adjusting your shutter speed, you simply adjust the power of your lighting heads as necessary. To adjust the depth of field, increase or decrease your aperture, bearing in mind that letting in more light with a wider aperture will mean you'll need to reduce the strength of the lights to avoid over exposed shots. To project your lights further, increase your ISO setting to make the sensor more sensitive.

Lighting techniques

A good starting point is to experiment with your lights by photographing a willing friend or partner in your own time. Set up a white backdrop and a basic two-light setup with umbrellas to bounce a softer light onto your subject. Position your main light (or key light) to the right of your subject, and then a fill light on the left that is set to a lower power than the key light. Take test shots and review them on your LCD. Increase or decrease the power of each light, reviewing your results each time until you have the desired shot.

Depending on how many lights you have, you could also add a third as a "hair light" to backlight your subject and lift them out from the background. For a pure white background, you may need another lighting head aimed at your backdrop. You may also find a reflector positioned underneath your subject's chin will remove unwanted shadows. As your confidence grows, start experimenting with more creative lighting setups.

Whether you're using flash or studio lights when shooting portraits, what you're looking for is that crucial catchlight in your subject's eyes—it's the magic spark that makes portraits come to life.

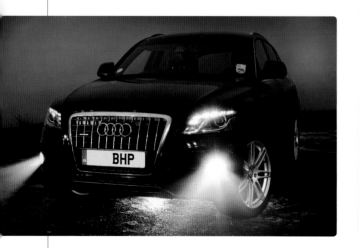

PRO TIP!

If you're using a flashgun, try to avoid lighting your subjects directly. Bounce the flash off a white wall or ceiling for a softer, more pleasing light. Better still, use your flash with a cable (or wireless trigger) and position the flash to one side or above.

Left > Practice, practice, and practice with your lights to learn which power settings work best for specific types of shots, exposures, and lens choices.

Above > Using portable flash lights will give you the opportunity to create striking images on location that would be impossible to shoot using just available light.

Right > With time and experience you'll learn to position your lights to capture really creative images, such as dramatic backlight behind your subjects.

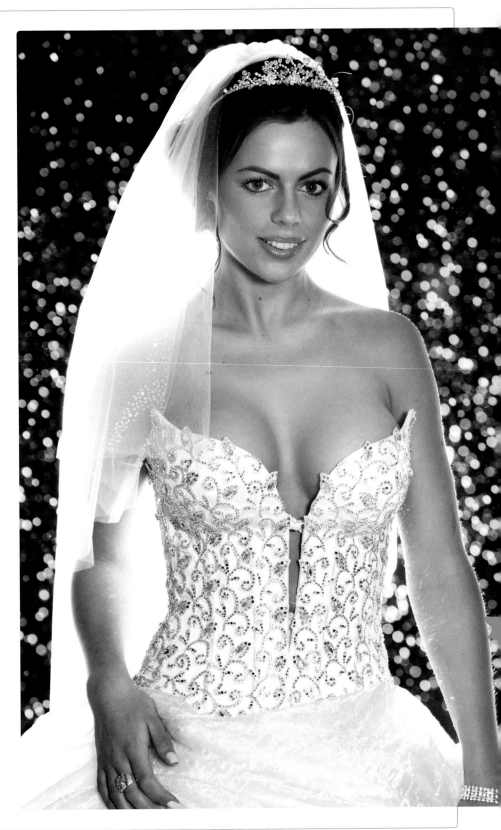

← 72
→ 73

HIGH ISO

If you're shooting lifestyle portraits, weddings, or food, product, or scenic photos without lights or a tripod, you'll need to learn to push your DSLR to its limits and trust its high ISO performance.

In the days of film, most photographers preferred to use film rated at ISO 100 for fear of grain ruining their results—unless they deliberately wanted a grainy effect. However, with the recent advances in high ISO technology in new pro DSLRs by the likes of Canon and Nikon, the days of noise ruining images at ISO 1600 or 3200 are long gone. It's now possible to capture immaculate images in low-light conditions with most modern sensors.

The more recent professional DSLRs offer an incredible maximum ISO setting of 102,400. While results at ISO 102,400 are predictably noisy, this means it's possible to achieve exciting and usable results at ISO 3200, 6400, and even 12,800 with minimal noise pollution.

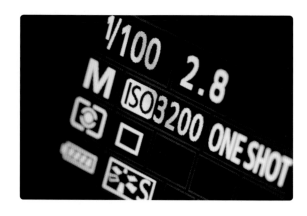

Making the most of natural light

The main benefit of shooting at high ISO settings is being able to obtain a sufficiently fast shutter speed to shoot handheld in low, natural light without suffering the blurred effects of camera-shake. Experiment with using just natural light and your DSLR's high ISO settings so you know the safest maximum ISO number you can use before the images get too noisy.

Whether manmade or natural, all lighting needs to be flattering when photographing your subjects or products. Avoid really harsh lighting as it creates unsightly shadows and unappealing and unprofessional results. Start off by using natural, soft light (not bright sun rays) coming in from a window. Build up to introducing a white reflector (for a natural light) to bounce light onto the unlit side of your subject to fill in the shadows. Also try getting creative by using candlelight or other subtle light sources for more evocative images.

PRO TIP!

When shooting with flash, you can use your ISO setting to increase the light's effective range. Simply increase your ISO so the light reaches a bigger area, this can be handy when shooting large products, such as cars, or when photographing large interior spaces.

Above > **With improved high ISO performance in modern DSLRs it's possible to shoot at ISO 3200 and even above without worrying about noise spoiling your shots.**

Top right > **High ISO settings enable you to shoot in dark indoor settings, using just light from candles and similar light sources.**

Right > **Higher ISO settings allow you to set fast enough shutter speeds to shoot cityscapes at night—without the need for a cumbersome tripod.**

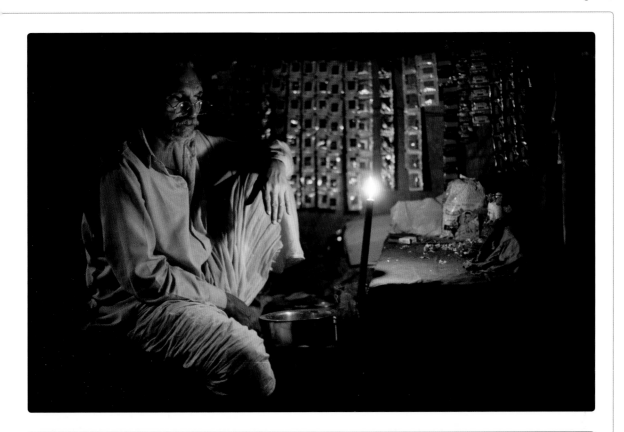

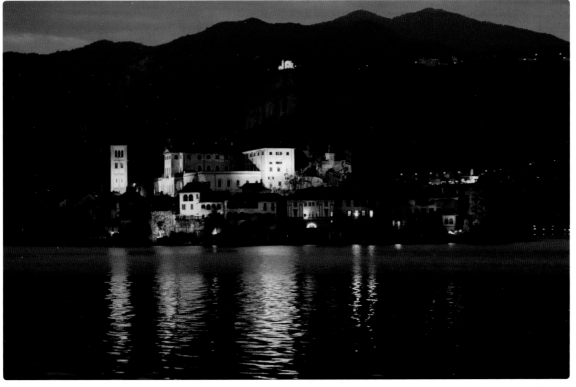

← 74
→ 75

WHITE BALANCE AND IMAGE QUALITY

To the human eye, white objects look white regardless of the lighting source. With a digital camera, the White Balance (WB), or color temperature, is adjusted by the camera's processor to ensure the white areas of your images look white. The Auto WB setting normally gets it right, but if your DSLR is struggling to capture natural-looking colors—images appear too warm (orangey-red) or too cool (blues and greens)—you can choose the White Balance mode to suit your light source.

White Balance modes include Daylight (or Sunny), Shade, Cloudy, Flash, Tungsten (or Incandescent), and Fluorescent; or you can manually set White Balance to the color temperature as a value in degrees (K) Kelvin, usually from 2,000–10,000K. High values are warmer color temperatures, and low values are cooler color temperatures.

It's good practice to use a Gray Card or Expo Disc (pictured opposite) attached to your camera's lens, to set White Balance when shooting under artificial lights, or on location when using only the available ambient light, such as streetlights.

Below > DSLRs have various White Balance settings to help you capture accurate colors whatever the lighting source.

Right > Use your White Balance presets, or shoot RAW and you can reset your White Balance during post-production.

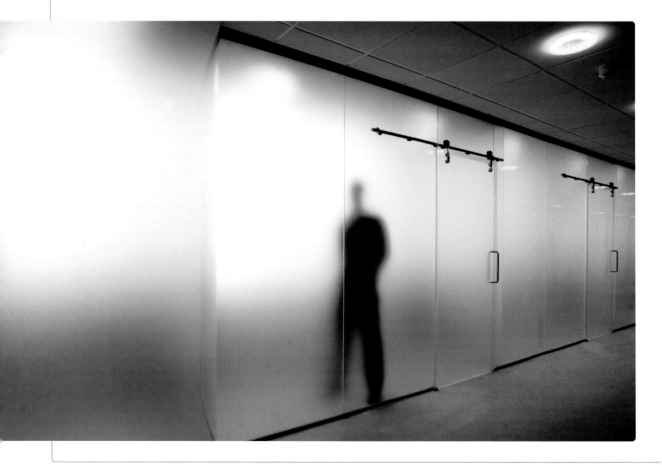

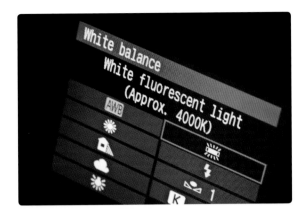

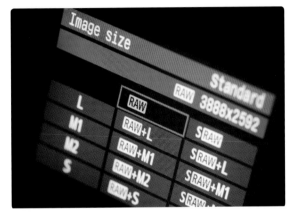

Image quality settings

The majority of pros shoot using the RAW file format. As its name suggests, with this format the file contains the raw, unprocessed data captured by the sensor at time of shooting. RAW images give you more control and greater options when processing your photos compared with JPEGs. For instance, you can increase or decrease exposure by up to 4-stops when processing a RAW file to accurately recover under or overexposed detail without loss of quality. Attempting the same correction on a JPEG would most likely lead to poor final image quality.

RAW files are like digital negatives, they retain the maximum amount of picture data. As RAW files contain unprocessed and uncompressed picture data, you need to process them into workable TIFF or JPEG files, using software such as Apple's Aperture, Corel's Paint Shop Pro, or Adobe's Lightroom or Camera Raw editor (which comes with Photoshop). When you make adjustments to RAW images, the original data is preserved (so you can always revert back later if necessary), and the adjustments are stored for each image as metadata embedded in a 'sidecar' XMP file.

PRO TIP!

Shoot in RAW and you can quickly adjust the White Balance of your images in Adobe's Camera Raw software afterwards using the Temperature slider— from 2,000–50,000K.

USING HISTOGRAMS

To check for exposure accuracy mid-shoot it's good practice to refer to your histogram—this is a graph that shows the tonal range of your images and can be viewed on your DSLR's LCD when reviewing shots.

On the horizontal axis of the histogram, darker tones appear on the left, midtones in the middle, and lighter tones on the right. The vertical axis shows the amount of pixels for each of the tones. If your images are overexposed, "clipped" highlight tones will bunch up against the right side of the histogram. If your images are underexposed, "clipped" shadow tones will bunch against the left side of the histogram.

Areas of your images that are clipped will be printed pure white or pure black and won't, therefore, contain any detail. For most exposures (apart from those shots with large bright or dark areas, see facing page for more) it's best to aim to capture a good spread of tones with a full and even histogram that has no clipped highlights or shadows.

Overexposed: All the pixel information is bunched to the right and clipped off the right-edge of the histogram.

Underexposed: All the pixel information is bunched to the left and clipped off the left-edge of the histogram.

PRO TIP!

Make sure your DSLR's LCD is calibrated correctly, otherwise any under/overexposed images may look fine on screen when reviewing your shots. Note that your LCD will appear brighter in a dark studio compared with outdoors when shooting in daylight. But always use the histogram reading or highlight warning to check for overexposed areas.

Correctly exposed: All the pixel information is contained within the histogram with no clipped highlights or shadows.

Highlights and shadows

When shooting a scene with a mixture of bright and dark tones, however, you will need to take control of your DSLR to accurately expose for the highlight or shadow detail. For example, when shooting a dark subject with a bright background behind and you want to expose for the shadow detail; or when you want to do the complete opposite and expose for the brighter background highlights behind your subjects to capture a creative silhouette.

This is when you need to use your experienced eye and decide what is the best exposure for the scene. You can also ignore the clipped highlights and shadows as, in these challenging lighting situations, it's likely that either one or the other will be clipped in order to achieve the "best" exposure.

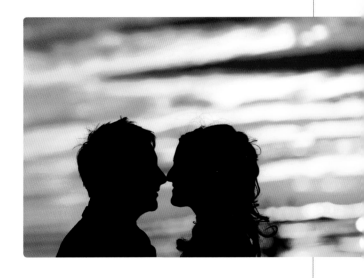

Above > Although histograms reveal tonal range, when you're shooting in a mixture of lighting, such as a silhouette against a sunset...

Below > ...or when your subject is darker than the background, it's up to you to decide the best exposure, for the best results.

← 78
→ 79

USING LIVE VIEW

One of the many benefits of modern DSLR camera technology is the ability to shoot using Live View. In Live View you can see a preview of what you're shooting, clearly on your camera's large color LCD. It can help make light work of shooting products, food, interiors, or gardens, and can work best if your camera is on a tripod.

With Live View setup, you can instantly see if your composition needs adjusting and whether your exposure needs fine-tuning to brighten or darken the potential image. It also enables you to accurately check the depth of field and whether you need to increase or decrease your aperture accordingly.

When shooting with Live View, it's possible to set up your camera so the histogram appears on screen, helping you to see the tonal range of your subject or scene all before you've pressed the shutter button.

Live View is also helpful when your camera is low to the ground, or in an awkward position, and it's difficult to get down to peer through the viewfinder.

Below > **Formerly viewed as a gimmick by some, Live View can make your life easier, especially for product or landscape photography.**

Right > **Live View enables you to check exposure, depth of field, and focusing at the press of a button—and all before you've taken a shot.**

Shooting tethered

Shooting in a studio with your camera linked directly to your computer is a great way to work. It means you—and your client—get to see the images instantly on a bigger screen, enabling you to see every part of the frame in detail. This can be invaluable when shooting in challenging conditions and you need to make sure the lighting is consistent and that you can see the important elements of your subjects clearly, or if you need to make lighting, lens, or compositional adjustments.

Shooting tethered also ensures your images are saved directly to your computer for faster working practices—while you shoot, your assistant can be processing images on screen ready to give to your client straight after the shoot.

Showing clients shots mid-shoot

If clients are keen to view images as the shoot is in progress or would like to see a sample afterward, make sure you provide what they need as this first impression of your images is very important.

Even when working on location, allow time to download your shots to your laptop, burning unprocessed images to disc, or printing a contact sheet if you have a portable color printer, so you can offer the client sample shots to take away. Sometimes this immediate turnaround will give you the advantage. The client needs be reminded that edited images will take longer, but this will give them an important flavor of the job.

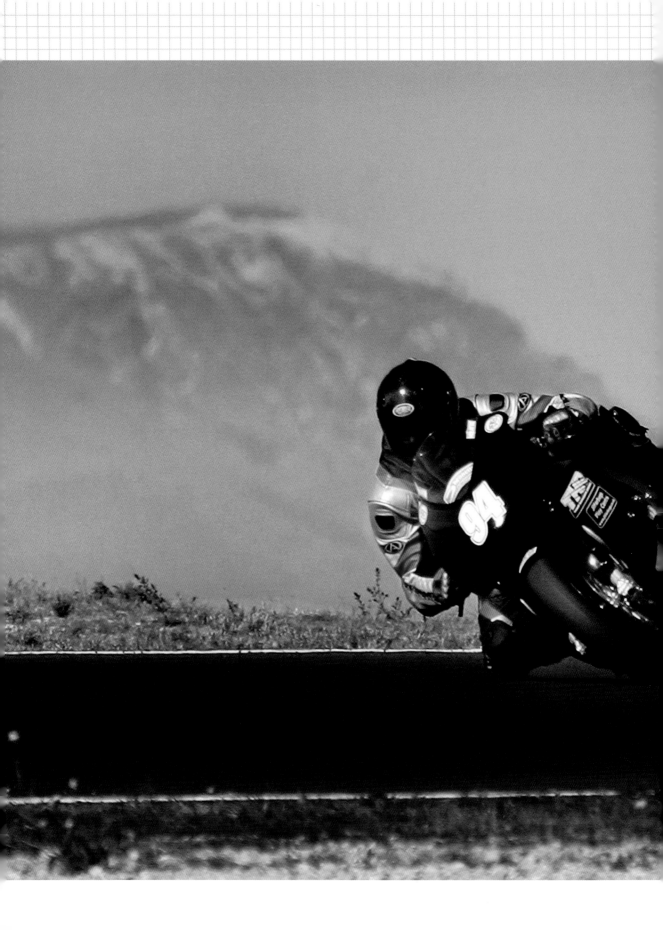

2.3

PRO PHOTO-SHOOTS

→ FOOD PHOTOGRAPHY

→ PEOPLE PHOTOGRAPHY

→ PRODUCT PHOTOGRAPHY

→ INTERIORS & GARDEN PHOTOGRAPHY

→ ACTION PHOTOGRAPHY

FOOD PHOTOGRAPHY

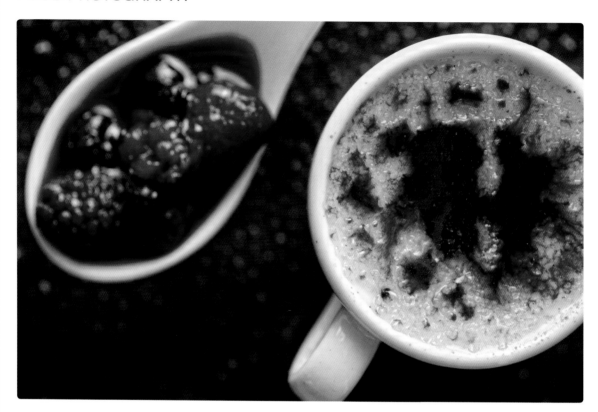

If the food you're photographing is fairly simple in nature, try and look at it as an abstract object. Discover what shape, form, or texture you can bring out in the way you light or place the food in the frame.

Sweet and simple

This image was taken for a large hotel chain that was refreshing their dessert menu. We only had an hour to shoot all ten new desserts on offer, so we had to make sure the setup was simple and easy to replicate. For this reason, the images were shot using a 24 inch (60cm) popup light tent and one Broncolor Mobilite head from above to give a good, even coverage. The client wanted part of the frame to be soft so that they could add clearly legible text. This was easily achieved using a wide aperture of f/4 at 1/125sec, ISO 320, with a 50mm macro lens.

Keeping it real

Using large, hot lights with a lot of food just wouldn't work. The days of painting a hamburger with food coloring, staining half cooked ribs with wood stain, and using ammonia and hydrochloric acid to make artificial steam—techniques used by pro food photographers in the past—are all somewhat dated now. Keeping it real and using only daylight, or small, less powerful lights, ensures your food won't melt—and knowing what type of shot you want beforehand will cut down shoot time considerably.

Above > A good tripod is essential for food photography—holding a heavy camera all day so close to food can be tough.

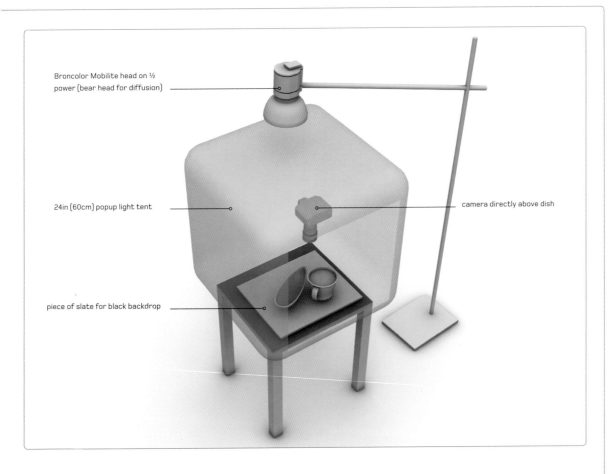

Broncolor Mobilite head on ½ power (bear head for diffusion)

24in (60cm) popup light tent

piece of slate for black backdrop

camera directly above dish

Manual focusing is generally best when shooting food. I often use Live View on a pro Canon DSLR and zoom into the object to check focusing is spot on. This means that I can keep the composition the same while focusing on different areas of the dish for a different depth of field.

PRO TIP!

Try and have a focal point to your food image. Certain foods, such as meat or fillets of fish for example, don't have any specific shape—unlike fruit or pies—which means that they can look messy. Make sure that the chef cuts regular, geometric-shaped pieces that can be dressed accordingly.

KIT LIST

→ Camera – Canon EOS-1Ds Mk III
→ Lens – Canon 50mm f/2.5 macro
→ Aperture – f/4
→ Shutter speed – 1/125 sec
→ ISO – 320
→ Broncolor Mobilite head & Mobil pack

FOOD PHOTOGRAPHY—SETTING A SCENE

Creating a scene around your main food setup can be a great way of putting the dish into someone's kitchen and onto their table. If you're shooting for a grocery store campaign, it's important to not only sell the food, but also the bottle of wine, glasses, bread basket, and napkins to go with it. Try using colors in the setup that complement the main dish nicely and will inspire customers to make the same meal.

Table manners

This image was taken using just natural light. Using a 70–200mm f/2.8 telephoto zoom lens at 70mm allowed us to get close enough to the food to fill the frame with the main dish and get in some background objects on the table as well. Angle of view is important here, if you go in too close with a wide-angle lens you will distort the food or shape of the dishes. Your chosen angle of view will depend on the background, sometimes it's better to get down low and shoot through the dish.

Stylist and subjects

If you're lucky enough to be working with a food stylist, most of the hard work will be done for you. Having someone to assist you with the food is invaluable as you will have enough to think about. Even if they just wipe the plate or arrange the background, it will save you time.

Also take advantage of the fact that your subject will move and settle over time. While a lot of food stylists say you only have a short time to work with food after it's served, that isn't always true (ice cream being the exception). I always feel that I can walk around, zoom, hover, and reposition dishes to get the shots I need.

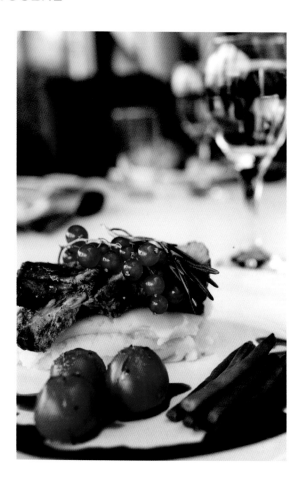

Above > **Keep the chef or soux chef on hand to help you clean and dress the dishes.**

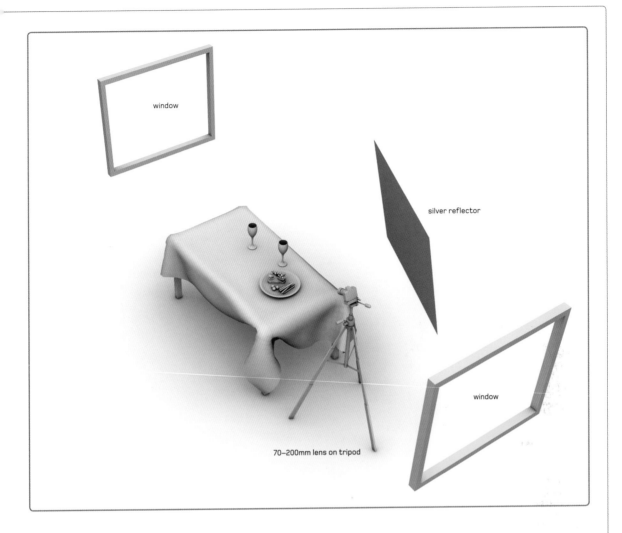

window

silver reflector

window

70–200mm lens on tripod

PRO TIP!

Get your White Balance right. There's nothing worse than getting the colors wrong, especially when the chef may have slaved over the dish for hours to get everything right. Don't over saturate the colors in the food; light it well and cleanly for accurate results.

KIT LIST

→ Camera – Canon EOS–1Ds Mk III

→ Lens – Canon EF 70–200mm f/2.8L USM

→ Aperture – f/3.5

→ Shutter speed – 1/50 sec

→ ISO – 800

→ Daylight

FOOD PHOTOGRAPHY—BUDGET SETUP

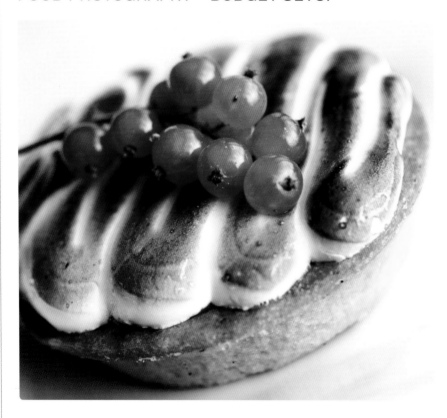

Left > Set up at the back of the kitchen near a window, out of the way. The food will have less distance to travel!

Modern food photography has gone back to basics. More and more cookbook publishers, chefs, food magazines, and advertisers request a natural look when photographing their dishes. This has made it easier for up-and-coming photographers to shoot food, as all you need is daylight. But this simplified approach is not without its difficulties.

Depth of field

This simple food shot of a tasty tart was for a catering company. When shooting food "au naturel" like this, you can opt to use a tripod or shoot handheld. If you shoot without a tripod then you'll have to increase your ISO to get a shutter speed fast enough to prevent camera-shake.

Bear in mind that at close quarters like this, with a macro lens at around f/8 you may not obtain a sufficient depth of field, depending on how much of the food your client wants sharp. This shot was taken with a 50mm macro lens, using an aperture of f/4 at 1/125sec, ISO 320.

Mix it up

Go in close and fill the frame. It's very important to shoot the food in different ways. Go in tight for a nice close-up, and then step back or zoom out a little and introduce a colored napkin, a basket of bread, a glass of wine, or a cup of cappuccino—whatever complements the dish and helps to add context.

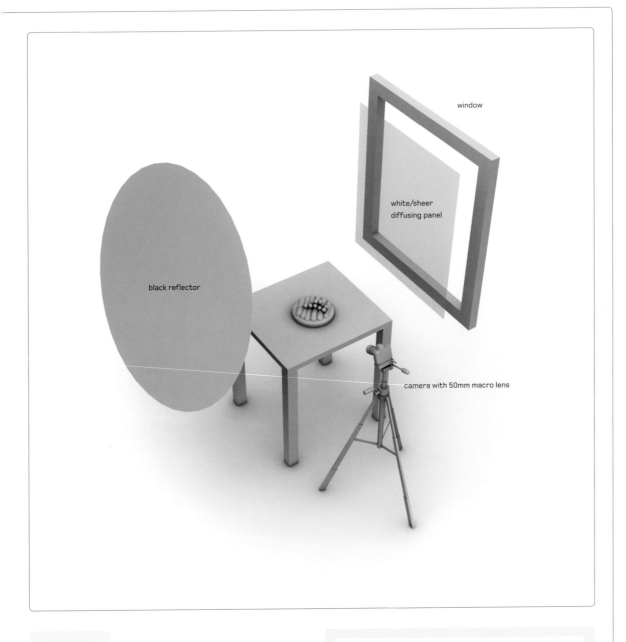

window

white/sheer
diffusing panel

black reflector

camera with 50mm macro lens

PRO TIP!

Shooting food out on location—as can happen a lot with chefs on site, preparing and cooking the food—brings its own challenges. Visit the kitchen or venue the day before the shoot to make sure you can set up lights if needed, or find a space in which there is enough natural light to work.

KIT LIST

→ Camera – Canon EOS-1Ds Mk III

→ Lens – Canon 50mm f/2.5 macro

→ Aperture – f/4

→ Shutter speed – 1/125 sec

→ ISO – 320

→ Daylight

FOOD PHOTOGRAPHY—PRO SETUP

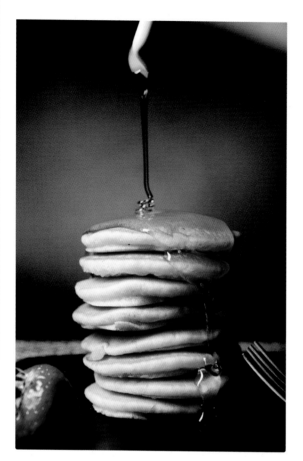

quality, which is ideal for foods such as syrup and honey. The backlight was set on minimum power to give some background fill to the wall, and using a hood I could keep the light focused to a centralized area.

A shutter speed of 1/250sec enabled me to freeze the syrup as it was poured over the pancakes. Shooting with a 50mm macro lens at f/5.6 allowed me to get very close to the food while keeping the depth of field shallow to draw attention to the pancakes and syrup. If the shot makes you feel hungry, then as the photographer, you know you are onto a winner!

Be prepared

Patience and planning are the keys to successful food photography. Find out exactly what the client wants; if they want an edgy look to the food you'll probably need lighting, if they want a more natural look, consider using natural window light to keep it simple and clean.

Photographing food is a very specialized area of photography and not one to be taken on lightly. America spends billions of dollars on food advertising every year so food photography is big business and can be very rewarding financially—if it is done right.

Keep it clean

This shot was taken in the studio to advertise a breakfast radio station. Using two lights I kept the setup simple but comprehensive. The main head was an Elinchrom Quadra A speed head using a 28 inch (70cm) square soft box with a cover that cuts out most of the light spread, concentrating it into a 2 inch (1cm) wide strip. This gives a very specular light

Make sure you do your homework beforehand, especially if you've never shot food before. Equipment such as a small water spray, cleaning cloths, different colored tablemats, napkins, polished utensils, along with photo equipment such as small reflectors, tripod, and a macro lens will all make your job easier.

Above > **Make sure you have enough of the food ingredients to use on the shoot. You may not get it right first time.**

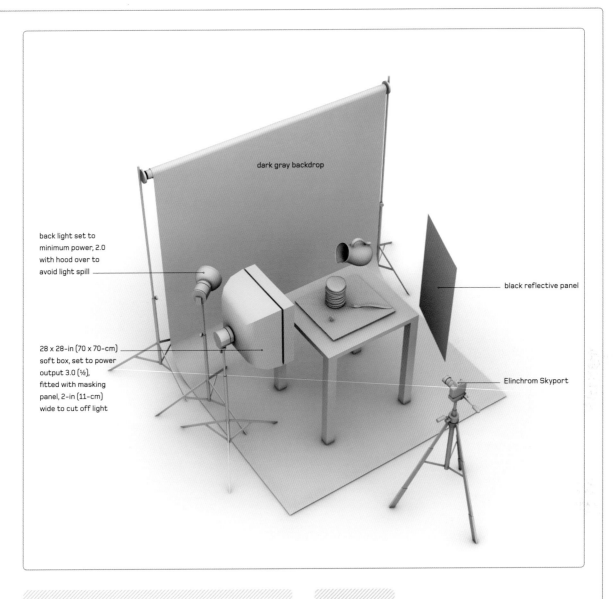

dark gray backdrop

back light set to
minimum power, 2.0
with hood over to
avoid light spill

black reflective panel

28 x 28-in (70 x 70-cm)
soft box, set to power
output 3.0 (½),
fitted with masking
panel, 2-in (11-cm)
wide to cut off light

Elinchrom Skyport

KIT LIST

→ Camera – Canon EOS–1Ds Mk III

→ Lens – Canon 50mm f/2.5 macro

→ Aperture – f/5.6

→ Shutter speed – 1/250 sec

→ ISO – 200

→ Two Elinchrom Quadra Packs with two A speed light heads.

→ One 28x28 inch (70x70cm) soft box with a mask cover
 panel fitted.

PRO TIP!

*Find out what the shots are to be used for. If they are
going into a book then you may not need to leave room
around the food for text. But, as in the brief for this shot,
it might be necessary to leave space at the top of the image
for the company's logo or other text.*

IVOR INNES / FOOD PHOTOGRAPHY

INTERVIEW

Ivor Innes is the son of freelance photographer and journalist Donald Innes. Ivor took over the running of the family business in 1970 shortly before his father died suddenly in 1971. He is one of the leading food photographers in the world and works for a wide range of leading blue chip corporations. His portfolio can be seen at www.innes.co.uk

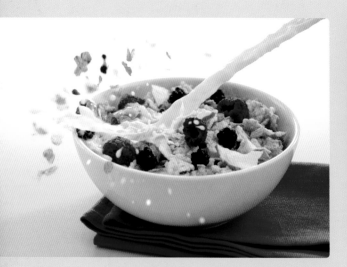

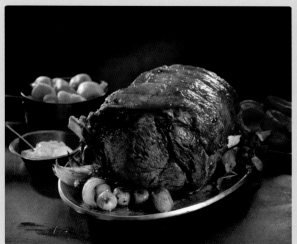

When did your interest in photography begin?

My interest in photography started at an early age. I was given the task of turning over the fixer in the dark room. I thought this was a very responsible job at the time!

How long have you been a professional photographer?

I have been working in professional photography for nearly 50 years.

What sort of food do you photograph?

I photograph all types of food and food accompaniments, fresh and frozen. Fish, meat, vegetables, dairy, everything.

Who are your main clients?

I have worked and still do work for blue chip companies, brands, and supermarkets. I have had a full range of clients during my career. Currently my main food clients are Asda, Brake Brothers Ltd, Thorntons Plc, Authentic Foods, and Sidoli. I have worked for Marks & Spencer, Paxo, Hovis, Knorr, Little Chef, Gardener Merchant, and many others.

What do you enjoy about photographing food?

I enjoy creating something from nothing. The main objective of the shot is to make you want to eat the food.

How do you approach each shoot?

Even now, I approach each shot with fear and trepidation. You can guarantee that the client will always want to change something, just when you have finished.

Do you regularly work with certain stylists?

I work with the same stylists most of the time. I have a pool of four that I use regularly and I get help from two to three others. Some clients bring their own stylists or chefs. It is very important to build up a rapport with your stylists but you have to remember that it is the photographer who is responsible for the shot, not the stylist, unless you are working with an art director.

IVOR'S KIT LIST

→ Hasselblad HD39

→ Imacon 3020

→ Phase 1 21

→ Sinar 43

→ Sinar monorail cameras

→ Nikon D3, DX3

→ Sinar monorail lenses 45mm, 55mm, 60mm, 80mm, 90mm, 105mm, 120mm, 180mm.

→ Hasselblad ELD lenses 40mm, 50mm, 60mm, 80mm, 120mm, 150mm, 250mm, 35–110mm zoom.

→ Broncolor lights

→ Bron HMI transformers and heads

→ Apple Macintosh computers

Farthest left > Although food is static, Ivor brings his food "to life" with creative use of motion capture.

Far left > It's important to shoot hot dishes the instant they come out of the oven to capture the food looking tasty and ready to eat.

Left > Using reliable stylists to help set up keeps Ivor free to compose and capture artistic shots.

When you are working for big brands and supermarkets, the art director is responsible for the shot and it is their call as to the appearance of the final shot. However, if possible, always try your own ideas. All shots are scaled into PDF files of the artwork, as I work. A lot of work is remotely art directed using VPN links and Skype or iChat.

Do you ever use special props or equipment?

I use only Bron lighting equipment, which is excellent. My special equipment includes lots of pieces of black and white card and broken mirrors! Lockable, adjustable clamps to hold reflectors are vital.

What advice would you give to beginners when photographing food?

When you are photographing food, don't hang about. Work out what you are going to do. Have a plan and stick to it. Photograph the food as quickly as possible once it is cooked.

What different techniques do you use to photograph food outdoors?

For outdoor work, I use lots of reflectors and diffusion material such as tracing paper. Keep out of the wind if you can. Always take an umbrella in case it rains. In sunshine, I often shoot into the light.

Any top tips you can think of?

Keep calm and have a plan; work out what you are going to do before you start. Select the lens and choose the view point before the final subject is ready. Have a mocked-up version prepared first. Make sure all your equipment is in good working order and all the digital settings are correct.

Do you do much image-editing to your photos?

I do a lot of image editing and stitching of images as I go along. I stitch five or six images to get the best viewpoint, and clone in some areas of the image that I shoot separately.

← 92
→ 93

PEOPLE PHOTOGRAPHY

When shooting models, in or out of the studio, make sure you know what you want to achieve. If you are using a model for a specific campaign, it's likely that there'll be an artistic director at the shoot to help you get the shot they need. Work with them to achieve the best shot for the client.

Fashion shoot

These studio portraits were shot for a fashion portfolio, using a two-light setup. I wanted very sharp images so I moved the lights close to the model to get a good mid-range aperture. Shooting with the lights on 1/4 power, we shot on f/10 at 1/250sec.

One light was positioned behind the subject on her left and one light just out of frame on the right. The right soft box had a strip in it to cut down on light "fall off," providing strong shadows. Directing the model's face toward the soft box enabled me to fill the face with light, concentrating on the eyes. This kind of lighting setup will not work for every face. You may want to try using a beauty dish or larger soft box to soften and spread out the light more depending on the individual's features.

PRO TIP!

As they say on "America's Next Top Model," make the model "SMIZE"—smile with her eyes. This is very important as the eyes can make or break a shot. Also ask the model to breathe through her mouth, this means she will slightly part her lips, making the face look more relaxed and sexy compared to a closed mouth.

Below > **Using lights at very close range shows up all the flaws of the skin. This kind of lighting won't work for everyone.**

Far right > **Watch the model, see how they move. The looking-down shot was an observation noted before the shoot started.**

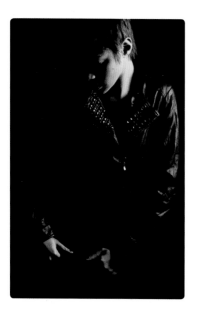

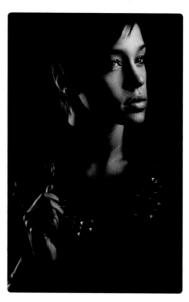

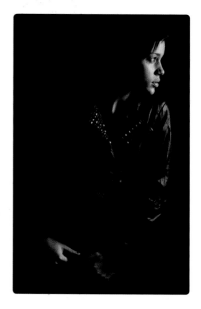

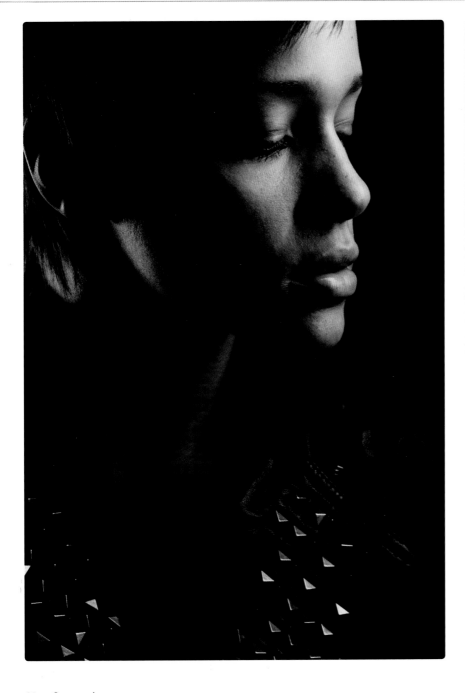

KIT LIST

→ Camera – Canon EOS-1Ds Mk III

→ Lens – Canon EF 85mm f/1.8 USM lens

→ Aperture – f/10

→ Shutter speed – 1/250sec

→ ISO – 100

→ Two Pocket Wizard Plus IIs remote lighting triggers

→ Two Broncolor Mobilite heads

→ Two 55x55 inch (140x140cm) Broncolor soft boxes

→ Dark gray background

Stay focused

Make sure you always use a makeup artist when shooting beauty and fashion portraits. This not only makes the model look their best, but also cuts down the amount of Photoshop and retouching required post-shoot.

When working in the studio environment stay focused, keep the shoot flowing, and don't let the shoot finish without covering everything you can.

← 94
→ 95

PEOPLE PHOTOGRAPHY—BABIES

You may think you've cracked portraiture if you're used to photographing different sorts of people from all walks of life, but if you're photographing babies or toddlers, you really have to raise your game. Welcome to the wonderful and unpredictable world of photographing babies.

Mix it up

This baby shot was taken during a private client session. I'd photographed their wedding and children before, but wanted to try to produce something a little different this time. It's becoming more popular to photograph kids with simple, natural light. However, for this shoot I wanted to take my fashion knowledge and desire for creative lighting, and bring it to the world of baby-lifestyle photography.

Shot in front of a white studio wall, I used one Elinchrom Quadra light head through a 28 inch (70cm) soft box off to the baby's left. We wanted to keep some shadow on the baby's face so we kept the light source quite simple. I shot on a low power setting with a Canon EOS-1Ds Mk III, Canon EF 70-200mm f/2.8 lens, with an aperture of f/5 at 1/200sec, ISO 200.

KIT LIST

→ Camera – Canon EOS-1Ds Mk III

→ Lens – Canon EF 70–200mm f/2.8L IS USM

→ Aperture – f/5

→ Shutter speed – 1/200sec

→ ISO – 200

→ Elinchrom Quadra light

→ One 28x28 inch (70x70cm) soft box with honeycomb rota grid

PRO TIP!

Work quickly with babies. Keep them warm and entertained and make sure the parents are involved in the shoot even if you're not photographing them. Make sure you have the baby's favorite toy or blanket near by, and remember that the baby decides when the shoot is over!

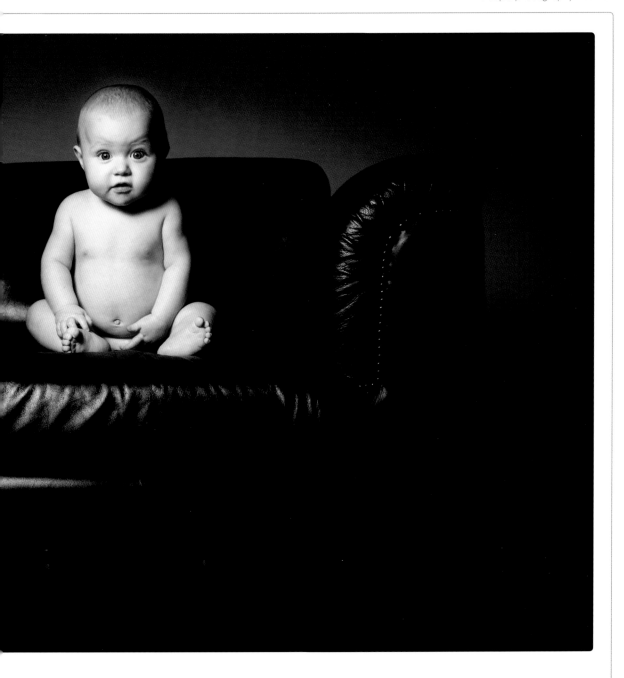

Express yourself

This shot works because of the baby's expression, and also because it's been photographed as a scene rather than just a close up of a baby. This kind of shot will only work if the baby is old enough to sit up—usually around six-to-nine months old—as this adds to the simplicity of the image.

Sometimes it's important to produce an image that the client would never have imagined. This way they will always come back for more just to see what you can do next time.

← 96
→ 97

PEOPLE PHOTOGRAPHY—BUDGET SETUP

You may not always be able to take your lights on jobs, especially if you're working overseas on location. Take your flashguns (strobes) with you wherever you go instead, you never know when you'll need them. They can make a huge difference and won't necessarily lead to inferior results.

Mix it up

This shot was taken during a wedding in France. We had 20 minutes on a hilltop with the couple, so I wanted to produce something a bit different. This shot was taken using three Canon 580 EXII Speedlite flashguns.

The main light on the couple was fired through a pop-up soft box to soften the light, set on 1/2 power. The second flash, fired to the left of the couple to light the cross, was set on 1/4 power, and had a red gel and hood to reduce any light spilling onto the couple. The third flash was set on full power and positioned behind the couple just in front of the old church building to give us a bit of separation and to illuminate the building. A red graduated filter was fixed to the lens to create a warm, moody skyline.

Don't forget to keep the shoot fun. Your head may be spinning with all the technical info, but the clients have to be kept at ease and entertained. Alongside a host of other images, I managed to produce some striking images of the newly married couple to give them beautiful memories of the special day.

Need assistance?

When shooting out on location it is important to have help. My assistant helped set up the flashguns and made sure they were all firing. The last thing you want to do during a wedding is have the couple standing around while you try and get the kit to work. Check everything the night before and then check it again. Once set up, the shot on the left took us about four minutes to create and execute.

PRO TIP!

When shooting a couple, it's important to ensure that they're both sharp in shot. Increasing the flash power gave me an aperture of f/8 to work with, allowing enough depth of field for both bride and groom to be in focus.

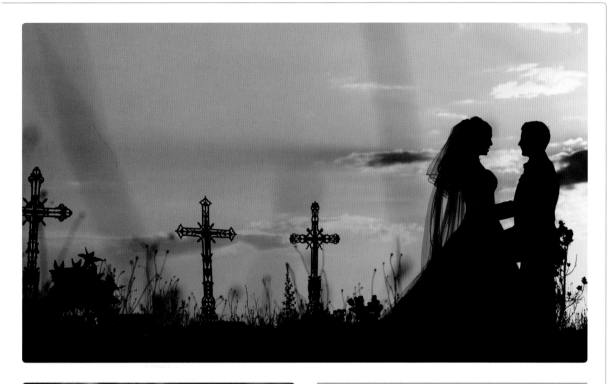

Far left > This shot took four minutes to set up. The bride's red shoes were the inspiration—look to the client to feed you ideas.

Above > Simple can be best. Underexposing by two stops gave me a perfect silhouette.

Below left > An assistant can be an invaluable part of a wedding or any shoot, freeing the photographer up to concentrate on creating beautiful images.

KIT LIST

→ Camera – Canon EOS-1Ds Mk III

→ Lens – Canon EF 16–35mm f/2.8L USM lens

→ Aperture – f/8

→ Shutter speed – 1/200sec

→ ISO – 250

→ Three Pocket Wizard Plus II remote lighting triggers

→ Three Canon 580 EXII Speedlite flashguns

→ Two Manfrotto Nano Stands

→ Lee Graduation filter (red)

PEOPLE PHOTOGRAPHY—PRO SETUP

Shooting for clothing companies can either involve photographing just the products or taking them into an environment with a model. If the latter is the brief, scout out a good location first and make sure it suits the clothing brand. Even if the client hasn't asked for any model shots, get the clothes onto a suitable model as the shots may just get you your next job.

Mix it up

This shot was taken for a teenage clothing brand. Shooting out on location can be great fun, but you have to use every situation you find yourself in and make the most of it. Halfway through this shoot, it started to rain, so I used this as an opportunity to capture an atmospheric portrait.

Shooting with two Elinchrom Quadra packs and two A speed heads I set up the main light and another 10 feet (3m) behind the model. The front light was fired through a 5 foot (150cm) strip soft box and the backlight was naked, apart from being covered with a clear plastic bag. I used a telephoto zoom to separate the model from the background. Working with an aperture of f/8 at 1/160sec, ISO 400 meant I could fire a strong light as the main light to provide good, full-body illumination, and also a sufficiently narrow aperture to ensure all the clothing was sharp in shot.

Day to night

Using a faster shutter speed than the ambience calls for results in "killing" the ambience. This can be a great way for turning day into night. It really works for certain clothing shoots in helping to highlight the pieces. Before using this technique, make sure you know what your client wants and the look they are going for.

PRO TIP!

Shooting in the rain takes preparation. Bring long, clear plastic bags or bespoke covers to protect your camera and lens, and more importantly, light heads or flashguns. Most cameras are reasonably weatherproof—that doesn't mean they're waterproof—but lights will be quickly ruined by any rain.

KIT LIST

→ Camera – Canon EOS-1Ds Mk III

→ Lens – Canon EF 70–200mm f/2.8L IS USM lens

→ Aperture – f/8

→ Shutter speed – 1/160sec

→ ISO – 400

→ Two Elinchrom Quadra Packs with two A speed light heads

→ 50x20 inch (130x50cm) soft box

Right > **Push the photo-shoot to the max. Try a variety of lighting setups. The last shot may just be the best.**

JAMES CHEADLE / PEOPLE PHOTOGRAPHY

INTERVIEW

James Cheadle is a professional portrait photographer who regularly shoots some of the world's most famous faces. Born in 1972, he began his photographic career at *The Bath Chronicle* in 1990. In 1992 James moved to a photo news agency to supply the national press, then in 1997 at EMAP publishing he became Staff Photographer on *Total Sport Magazine*, photographing many of the world's top sporting figures. Since 2000 James has been working as a successful freelance photographer, and regularly undertakes commissions for a host of different international clients. Recent clients include: *Loaded, Q Magazine, Bike, The Sunday Times, Night & Day, Golf World,* Deloitte, Pernod Ricard, *Today's Golfer, BBC Music, FHM, Men's Health, T3,* and *Performance Bikes.* Find more at www.jamescheadle.com

When did your interest in photography begin?

I first became interested in photography when I was nine years old and on a family holiday in the south of France. My dad let me play with his Practika SLR. I spent the fortnight shooting anything that moved on the old farm where we were staying.

How long have you been a professional photographer?

I've been working full time as a photographer since 1993, before which I ran the black-and-white darkroom at my local newspaper for two years.

What sort of people do you photograph?

How long is a piece of string. In the last few weeks, I've photographed drunken rock stars, Olympic gold medallists, a children's TV presenter, and a famous movie director.

Who are your main clients?

I work mainly in editorial, so I have a core of about ten magazines in America and the UK that book me on a regular basis. These are mainly lifestyle and sports titles. About 20 percent of my time is spent shooting for more corporate clients such as Deloitte, Pernod Ricard, and Phillips.

What do you enjoy about photographing people?

Nearly every day I meet someone new, and due to the nature of the people I shoot I'm lucky enough to meet real individuals with unique talents. I think it's fair to say that I take something away personally from every encounter.

How do you approach each shoot?

I treat every shoot as if my career depended on it, which to a certain extent, it does. There's an old saying in this business that can ring very true, "You're only as good as your last shoot."

Do you feel it's important to be organized and disciplined as a freelance photographer?

When it comes to organizing a shoot, yes I'm very organized. There are just no excuses for making mistakes as far as most clients are concerned. I always over prepare for every shoot. No stones are left unturned.

Do you prefer to work against a shot list or do you prefer to take control and shoot as you see the person and conditions before you?

Shot lists can be very useful and sometimes absolutely essential to fulfil the brief. It's impossible to say whether I like to work with them or without them, as some shoots just have to have them—they become as important as your camera. There are occasions where you have to be flexible with shot lists as things don't always run to plan.

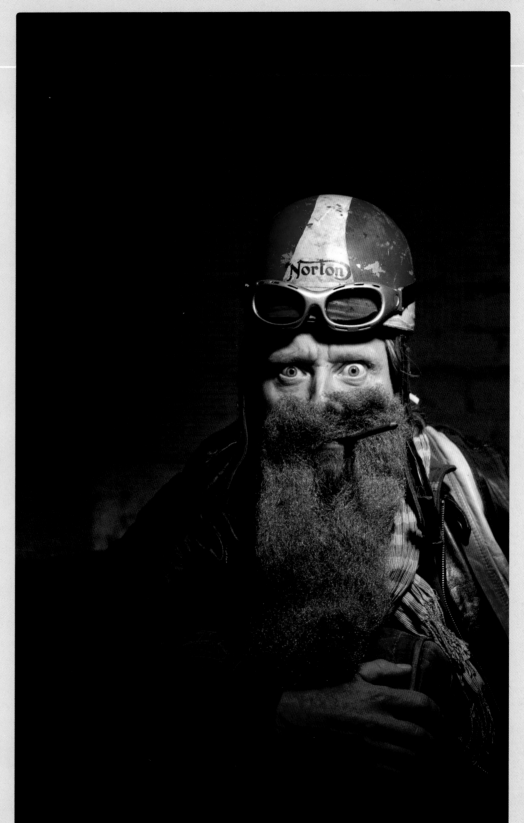

Right > As part of his core editorial portrait photography work, James Cheadle gets to meet some truly unique individuals, such as the adventurer and actor Charley Boorman, disguised here in a crash helmet and fake beard.

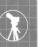

JAMES CHEADLE / PEOPLE PHOTOGRAPHY

INTERVIEW

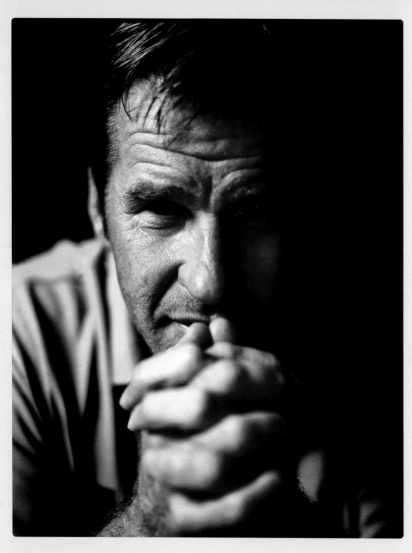

Left > Golfer Nick Faldo in an intense mood.

Right > A dramatic shot of Australian golfer Greg Norman.

You've worked with some big names over the years, how do you handle working with big personalities on shoots?

Everyone has their own ideas on how to treat celebrities. Personally I treat everyone, regardless of who they are, with complete respect and warmth. It's important to be able to read people quickly, as what's acceptable to be asked of one person can be completely insulting to another.

Do you ever use special props or equipment?

Not really, all of my kit is quite standard. It's not what you've got but what you do with it that counts.

Is there anything specific you need to consider when shooting for magazines or advertising?

There are always specifics to keep in mind with every shoot. Each job brings with it its own challenges and opportunities.

Which are your favorite techniques?

A favorite technique of mine is to shoot into the sun on a bright day and expose for the sky while lighting the subject from the front or side. The sky is the most versatile background out there.

Do you favor a certain lens? Or a certain lighting setup?

I'm not a particularly "techie" photographer so I don't really get attached to any specific pieces of kit. I just have a box of tools to get the job done.

How do you handle direction and suggestions from several people (art directors, stylists, etc) on shoots?

I welcome good direction on shoots, so long as it's coming from the right person. A good art director is worth his or her weight in gold.

What skills do you think you need to make it as a good professional portrait photographer?

You need to be good with people, but also enjoy communicating with them. A solid knowledge of the ins and outs of the equipment is equally important. Lastly, you really need to have a sense of style and an understanding of your clients' needs.

JAMES' KIT LIST

→ Canon EOS-1D Mk IV

→ Canon EOS-1Ds Mk III

→ Canon EX580 II Speedlite flashguns

→ Pocket Wizard radio triggers

→ Canon EF 70–200mm f/2.8L IS USM

→ Canon EF 24–105mm f/4L IS USM

→ Canon EF 16–35mm f/2.8L USM

→ Canon EF 300mm f/2.8L IS USM

→ Bowens Esprit lights

→ Elinchrom Quadra lights

→ Apple Macbook laptop

→ Apple iMac desktop computer

Do you do much image-editing to your photos?

I don't go crazy with the post-production. Personally I'm not too keen on imagery that looks unreal or false unless there's a very good reason. I do like to use all the available software out there to my advantage though, but hopefully in a way that maintains the personality of the subject.

What advice would you give to beginners embarking on a career in portrait photography?

Be prepared to graft for the first few years for low pay. There's an amazing career to be had if you have the talent, but good things only come to those who are prepared to wait.

Any top tips you can think of?

Always treat your clients with respect. Always put 100 percent into every shoot, regardless of how dull it may seem. Always arrive early for every shoot. Always buy the best kit you can afford.

PRODUCT PHOTOGRAPHY

A great deal of product photography involves shooting objects that have reflective surfaces. This can cause a problem when shooting with lights as there will be unwanted reflections and highlights appearing in all the wrong places. This is especially common when shooting shiny new bikes, cars, and motorbikes. Before you start, make sure that all visible parts are clean and polished—if possible get your assistant to help, otherwise it'll be a long shoot!

The right angles

These shots of a high-end Cervélo triathlon bike were taken for a triathlon magazine. It's important to shoot with the right lens and from the right angle when shooting bikes. You don't want to distort the angle of the frame with a wide-angle or telephoto, so stick with standard focal lengths of between 40–60mm. Shooting either side on or having the bike angled with the front leading slightly away from the camera will provide an accurate composition.

These shots were taken with two light heads set on 1/4 power through two soft boxes, one at the rear and one to the right. I shot with an aperture of f/11 in order to get maximum depth of field, with a shutter speed of 1/250sec. Putting a light at the rear of the product also helps to separate the black parts of the product from the background.

Color brands

Make sure you know what the client wants out of the shoot. It is very important that you are on the same page in order to fulfill the brief. When shooting products with branded colors, make sure you set the White Balance using a gray card in order to accurately capture the precise colors of the product.

PRO TIP!

When shooting large products such as bikes, either use strong weights or a wire suspended from the ceiling to hold the bike in position. If you don't have either then get someone to put their finger on the saddle or handlebars to hold the bike in position—this can be edited out easily during post-production.

Below > Using a piece of wire to hold the bike upright can be a good way of keeping the bike steady. Photoshop it out afterward.

Right > Capture a combination of close-up detail shots with longer shots showing the entire product in the frame.

KIT LIST

→ Camera - Canon EOS-1Ds Mk III
→ Lenses - Canon 50mm f/2.5 Macro 2.5, Canon EF 16–35mm f/2.8L and Canon EF 24–70mm f/2.8L
→ Apertures – f/8–f/11
→ Shutter speed – 1/100–1/250sec
→ ISO – 125–400
→ Two Broncolor Mobilite Heads, 1/4 power
→ Two soft boxes
→ Manfrotto tripod and Pistol grip head

PRODUCT PHOTOGRAPHY—ON LOCATION

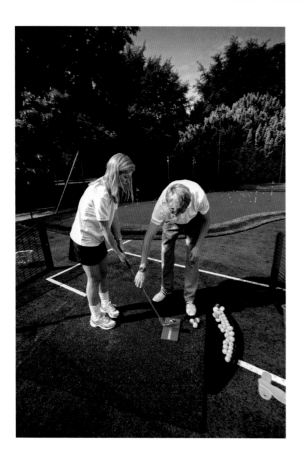

Products on location

This was a fun shoot for EuropeanGolf.co.uk and Teen Golf, shooting their products on location. Shooting outside brings different challenges—not only do you have to contend with erratic light levels, but you also have to find suitable backgrounds, and be aware of product placement, to name a few. However, it shouldn't stop you fulfilling the brief and capturing the shots desired by your client.

For these shots I used a Canon Speedlite 580EX II flashgun through a Lastolite Ezy box, off to one side, to simulate strong, low evening sunlight. By slightly underexposing the products I could bring out the strong colors against the dark grass. Using a flash light source at an angle to the product is a great way of getting good depth to the image.

Left > Get people into the shoot. Don't just capture the product, create the lifestyle to go with it.

Below right > Waiting until the sun was lower in the sky made it easier to deal with contrast.

You may be asked to shoot your client's products on location. Depending on where you're shooting, this means light levels may not necessarily be consistent, or worse, it could start to rain. Whenever on location, be prepared with extra lights and props to help you to achieve your goal.

PRO TIP!

When shooting products of any kind, remember to capture the colors as accurately and as faithfully as possible. You need to ensure that your color management is consistent throughout your entire workflow.

KIT LIST

→ Camera – Canon EOS-1Ds Mk III

→ Lens – Canon 50mm f/2.5 Macro

→ Apertures – f/9–f/11

→ Shutter speeds – 1/125–1/200sec

→ ISOs – 200–400

→ Lastolite Ezy Box

→ Two Pocket Wizard Plus II remote lighting triggers

→ Canon Speedlite 580EX II flashgun

→ Manfrotto Nano stand

Creating a lifestyle

Use the time you have with the products on location to your advantage. If at all possible, get people using or wearing the products. Placing the product with someone who fits the client's target demographic creates a lifestyle that goes with the product, and this can make all the difference. These shots can often be used alongside the shots of the products, and together they will help to sell the items better. If their products look good in your image, the client will be sure to use you again.

Left > Don't be scared of going in close on the items. Lighting them from the left meant that I didn't get in the way of the output.

Below > Using small apertures of f/11–f/16 keeps everything sharp from front to back. Very important when working with products.

← 108
→ 109

PRODUCT PHOTOGRAPHY—BUDGET SETUP

It's certainly possible to produce stunning, well-lit product shots with even the most basic lighting. Try using just window light and a table, for example. With skill and patience you'll be able to make the products look like they were shot in a studio environment.

Simple shoot setup

These leather boots and shoes were shot for commercial boot company, John Whitaker International, using just a tripod and a small window at the back of the studio. The shoes were put onto a table with a white piece of sheet plastic underneath to keep the background clean and for the client to be able to cut them out for their advertising and brochures.

I simply taped off sections of the window to give me the strip down the shoe that I needed. You could easily reproduce the shot or effect by taping down part of your soft box to a strip. If the light from the window is too strong then cover it with a sheet or a large piece of tracing paper for a nicely diffused light. Make sure that you can reproduce this effect if the client comes back to you and wants more.

To keep the background clean and white, try putting a flash gun under the table and fire it through the plastic. If you slightly overexpose the shot you will keep the white and not lose it. All of these shots were taken with a 50mm f/2.5 macro lens, using a mixture of shutter speeds and aperture settings depending on what depth of field was needed.

KIT LIST

→ Camera – Canon EOS-1Ds Mk II

→ Lens – Canon 50mm f/2.5 Macro

→ Aperture – f/2.5–f/5.6

→ Shutter speed – ½–1/200sec

→ ISO – 200

→ Table and white plastic

→ Window light

→ Manfrotto tripod and Pistol grip head

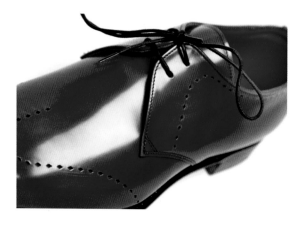

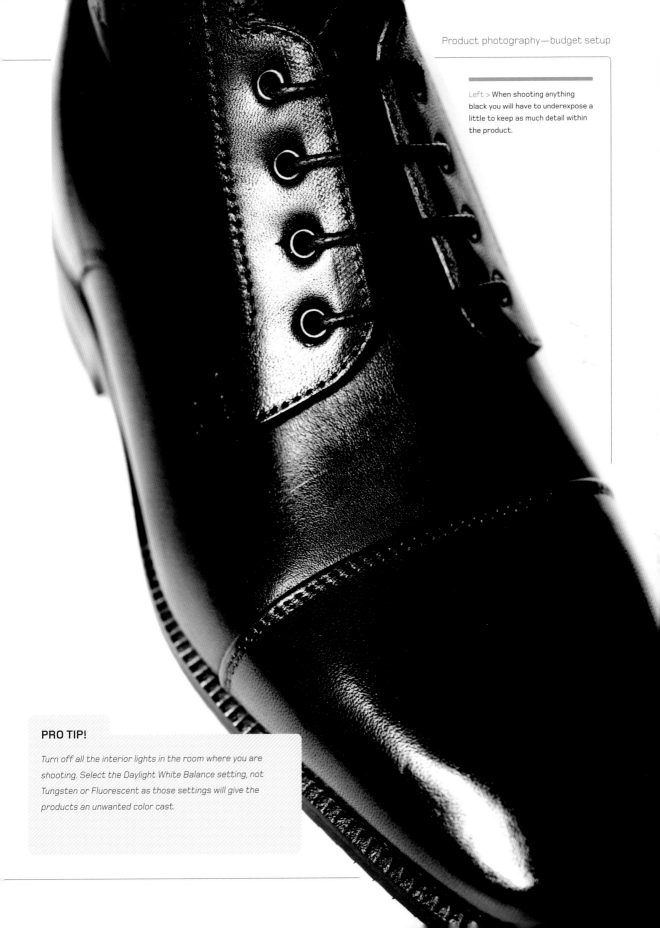

Left > When shooting anything black you will have to underexpose a little to keep as much detail within the product.

PRO TIP!

Turn off all the interior lights in the room where you are shooting. Select the Daylight White Balance setting, not Tungsten or Fluorescent as those settings will give the products an unwanted color cast.

PRODUCT PHOTOGRAPHY—PRO SETUP

Photographing products can be daunting—it involves making inanimate objects appear full of life and character. But don't let this hold you back. With a little preparation, and the right equipment and setup, it's possible to create images that really lift out the object and make it desirable.

Watch out

The image of this Swiss-made Oris watch was taken in a small 24 inch (60cm) light tent for a soft, even light. I used two lights, one either side, each set on 1/2 power. The close proximity of the lights provided effective specular light. I used a small red card near the camera to throw a little color into the minute markers, while different shaped white cards positioned near the watch at different angles were also used to throw light back where needed.

The watch was stuck down to the base plate with a small amount of blue adhesive putty to hold it steady, with a jar lid inside the bracelet strap to keep it rigid. One potential problem when shooting glass at close quarters is unwanted reflection. To prevent this, I draped a black cloth over the camera and down toward the watch—using the camera's 10-second timer allowed me to make sure the cloth was clear of the shot when the camera fired. The position of the watch hands is also important— around ten minutes past ten o'clock visually works best.

Keep a record

The initial setup for products such as this can take time, but once you've mastered it, then shooting similar products will be plain sailing. Make sure you write down information about the setup before you pack away the shoot, and take a snap of the setup for your records so you can copy it quickly when the next job comes around.

PRO TIP!

When using close-quarter macro lenses you will need to work with a narrower aperture than you might think. An aperture of f/14 was used for this shot because the watch was positioned flat to the camera. Objects that are leaning slightly away or not parallel to the camera will require an even narrower (f/22) aperture to get sufficient depth of field.

KIT LIST

→ Camera – Canon EOS-1Ds Mk III
→ Lens – Canon 50mm f/2.5 macro
→ Aperture – f/14
→ Shutter speed – 1/250sec
→ ISO – 160
→ Three Pocket Wizard Plus II remote lighting triggers
→ Two Ranger Quadra lights A heads
→ Two Manfrotto Nano Stands
→ 24in (60cm) light tent
→ Several reflective lighting cards

Right > Make sure that all interior lights in the studio are switched off as this may effect exposure and create color casts.

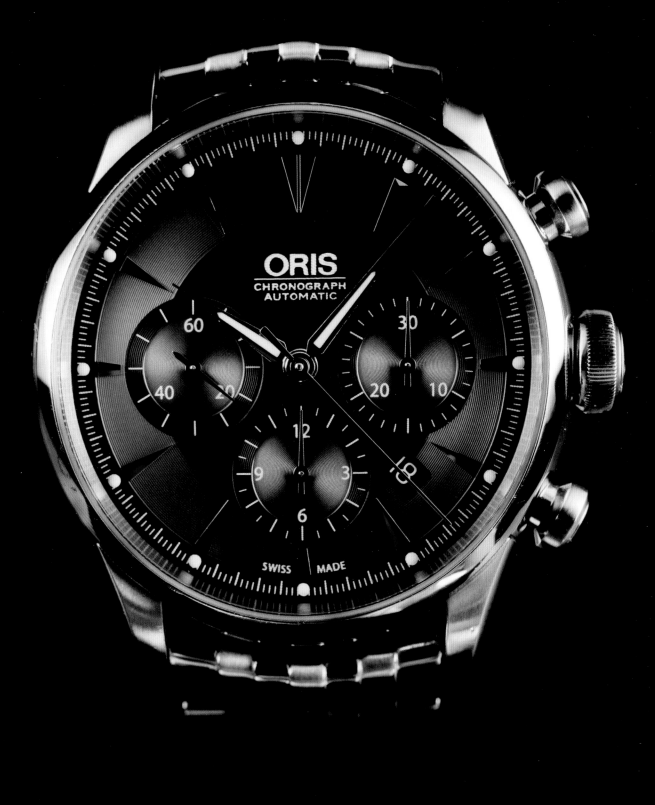

JONNY GAWLER / PRODUCT PHOTOGRAPHY

INTERVIEW

Jonny Gawler specializes in product shots and car photography for numerous big-selling publications. His studio, Flow Images, is based in Bristol, UK. More information and a gallery of his work can be found at www.flowimages.com

How long have you been a professional photographer?

I started making money from photography when I finished college in 1993 and I've made my living solely from photography since 1995. We—my business partner, Ed, and I—have been here at the Flow Images studio since 2006.

What sort of products do you photograph?

Cars and bikes; bicycles and parts like wheels, cranks, handlebars, and seats; sportswear such as wetsuits, shoes and clothing, sports accessories, bags, and sunglasses; cameras, lenses, and computers.

Who are your main clients?

My product photography is nearly all magazine editorial grouptests for Future Publishing and Origin Publishing. They need everything shot from the same angle with the same lighting and one-off full page and DPS (double page spread) pictures.

What do you enjoy about photographing products?

Lots of different magazines run grouptests so there's enough variety to keep it interesting. There's always a technical challenge or a new photography technique to try, and there's a great range of materials and finishes now so I like coming up with lighting that complements them.

Do you ever use special props?

Most products stay in place by themselves or with a bit of Blu-Tack! For consistent pictures of clothing we use mannequins—both rigid and flexible ones.

What advice would you give to beginners when photographing products?

Remember that it's not about showing off your skills and talent, but about the photographic presentation of the product following your client's requirements. Because everything is under your control there are no excuses for your images not being up to scratch. Think about how to show (or hide) various features and stick to the client's editorial page design. Bear in mind technical issues like color fidelity and how the focus falls off (or doesn't), and creative decisions like helping to come up with the arrangement and choosing a background color to follow the theme set by the art director.

Anything specific you need to consider when shooting for magazines?

Apart from the appropriate lighting and backdrop colors to suit the publication's style, don't forget to include space for editorial headlines and text in your composition.

What different techniques do you use to photograph products outdoors?

You can think of the outdoors as a studio too because there's a choice of backgrounds already set up and a light already on. But, unless you want to cart a load of kit around with you I try to keep it simple, maybe one flash and a collapsible reflector.

Below > An experienced pro, Jonny gives static products life with creative compositions.

Right > A large studio enables Jonny to shoot products from sports cars to sports shoes.

JONNY'S KIT LIST

→ Canon EOS 5D Mk II DSLR

→ Canon EF 24–105mm f/4L lens

→ Nikon D2x DSLR

→ Nikon D3 DSLR

→ Nikon 24–85mm AF f/2.8–4D

→ Nikon 70–200mm f/2.8 AF–S

→ Nikon AF prime lenses 35mm f/2D, 50mm f/1.4D
 and 85mm f/1.4D

→ Mamiya 50mm shift lens with mount adaptor

→ Arri 1kw and 2kw tungsten lights

→ Bowens 500 and 750 mono lights

→ Manfrotto studio stand

→ Manfrotto Expan system on the wall for wide
 Colorama rolls

→ Quantum radio slave flash triggers

→ Apple Macbook Pro laptop with 24 inch screen for
shooting tethered

INTERIOR PHOTOGRAPHY

Shooting interiors is a specialized facet of photography. Many interiors call for specialist tilt and shift lenses (to straighten converging vertical elements of buildings), extreme wide-angle lenses, a good knowledge of lighting, and lots of patience, but it's a branch of photography that can bring its own unique sense of satisfaction.

Get them moving!

This shot was taken for a commercial brochure for The Lowry Theatre. The brief was to show the interior expanse of the building as well as capturing some energy and life by including people in the shots. Using a tripod and wide-angle lenses, I got various shots between 1/20 to 2 seconds for different degrees of motion blur. You may need to use Neutral Density filters if the lighting inside your venue is too bright to use such long exposures.

I always try and fill the frame with color if it is there. Look for a focal point, a way for the viewer to visually travel in, around, and out of the image. Try and work out what the dominant light source is and change your White Balance accordingly. Shooting RAW will allow you to change your White Balance afterward if needed.

Watch out for windows

Avoid windows if at all possible, especially if you need a slow shutter speed. Shut the curtains or blinds if necessary. Remember that darker areas of the room or interior need a longer exposure than the brighter areas. Try taking multiple frames and then overlapping them with an HDR technique. This can give you the best of both worlds with detail in the highlights, mid-tones, and shadows—and makes a perfect exposure a lot easier to achieve.

Below > Using a long shutter speed means you don't capture anyone's identity, thus taking away the need for model release forms.

Right > Try to fill large, blank areas of the frame with a foreground point of interest. This plant worked very well here.

PRO TIP!

If you are going to show anyone's identity in an image, it's good practice to get the person to sign a model release form. This will give you permission to use the images for commercial release. Using a long exposure, and blurring people in your shots is another way of hiding their identities.

KIT LIST

→ Camera – Canon EOS-1Ds Mk III

→ Lenses – Canon EF 15mm f/2.8 fisheye and EF 16-35mm f/2.8L

→ Apertures – f/8–f11

→ Shutter speeds – 1/20sec–2sec

→ ISO – 100

← 116
→ 117

INTERIOR PHOTOGRAPHY

Certain interiors call for more dramatic photographic treatment. This can either be in the way you light the space or use natural window light, or the lens that you choose to use, or both.

Go wide!

Using a fisheye (8mm to 15mm) lens for interiors is a great way to capture large spaces while keeping depth of field to a maximum. Whether using just daylight or flash, I would always recommend turning on as many interior lights as possible. This will improve the ambience of the room.

Both of these shots of a grand wedding venue were taken with a Canon EF 15mm f/2.8 fisheye. The horizontal shot was taken metering the exposure from the windows, which meant all the highlights were retained.

Shooting handheld

I prefer shooting interiors handheld if possible, as it's faster and I have greater freedom to find the best spot to shoot from. I used fairly high ISO settings for these shots—the horizontal image was shot with ISO 500 and 1/200sec at f/7.1, the vertical image was taken with ISO 640 and 1/60sec at f/4. Today's DSLRs have great noise control, so it's possible to use high ISOs if you don't have or want to use a tripod. In addition, the depth of field is still wide even at these apertures because of the short focal length of the wide-angle lens, which naturally captures greater depth of field.

With interior images it's important to find a good focal point for the room; such as the violinists and chandeliers in the shots here. For the vertical shot I set a custom White Balance with an Expodisk, taking it from the main light source of the chandelier, aiming to keep some warmth within the shot.

Below > Using a fisheye lens adds impact, but if the client wants straight verticals then use a lens with a longer focal length.

Right > The red carpet creates a strong leading line for this shot. Look for details that you can use to guide the viewer through the image.

KIT LIST

→ Camera – Canon EOS-1Ds Mk III

→ Lens – Canon 15mm fisheye

→ Apertures – f/4–f/7.1

→ Shutter speeds – 1/60–1/200sec

→ ISO – 500–640

→ Expodisk

PRO TIP!

To find inspiration, try looking through interior or home magazines. Look at how they lay out the rooms and make certain objects prominent within the frame. Collect cuttings and keep an ideas' book. Practice in your own home or ask permission to shoot your favorite hotel or restaurant to get your techniques right before using the skills on a real job.

← 118
→ 119

GARDEN PHOTOGRAPHY

Gardens are an area of photography that's open to everyone, regardless of skills, experience, or budget. With minimal camera gear, all you need is a garden laden with colorful flowers, and a good eye for light, form, and texture.

Early birds

You couldn't wish for a more peaceful environment in which to work than when whiling away a few hours as you relax and photograph beautiful gardens. These idyllic locations can at first seem easy to shoot, but it's all too easy to end up with uninspiring photos unless you follow a few simple rules. Try visiting the garden late in the summer evening or first thing in the morning. This will not only give you a better chance of shooting in beautiful, soft, warm light, with longer shadows for added depth in your shots, but it also means there will be fewer people to potentially obstruct your view.

Try including a focal point in your shots—in the shot on the right, the path in the middle of the frame draws the viewer in. The hint of a house at the bottom of the garden makes the viewer want to find out more. This image was taken in low evening sun to emphasize the colors of the foliage. Shot using a 50mm f/1.2L lens, ISO 125, 1/2500 sec at f/1.2, the shallow depth of field also helps to draw the viewer into the scene and creates a colorful, almost painterly effect.

Natural patterns

Composition is the key to success. Keep it simple. Look for natural patterns within the garden and landscape. Let the foliage and light dictate where you should be shooting from. Look for strong focal points, garden sheds, fountains, and doorways into secret gardens.

Top right > Mottled sunshine is a necessity for garden photography. Sunshine at either end of the day will provide the best quality light.

Below right > When working with a dull gray or white sky, try using a gradient filter to give the sky some impact and interest!

PRO TIP!

Take a tripod, as sometimes you may want to maximize depth of field with a narrow aperture of f/22, while using the resulting slower shutter speed to capture the swaying trees or water movement in fountains and streams. Shooting early and late with low light will demand using a tripod as there won't be enough light to get sharp shots if shooting handheld.

KIT LIST

→ Camera – Canon EOS-1Ds Mk III

→ Lens – Canon EF 50mm f/1.2L USM

→ Aperture – f/1.2

→ Shutter speed – 1/2500sec

→ ISO – 125

→ Manfrotto tripod with Pistol grip

← 120
→ 121

GARDEN PHOTOGRAPHY

When photographing gardens, it's a good idea to capture both wide, landscape views, as well as tightly focused details of individual elements, flowers, and plants within the garden—that way your images tell the whole story.

The beauty is in the detail

It's important to look for beautiful details when shooting gardens, and a good way of bringing your garden shots to life is to include nature and insects, such as the example here with a colorful butterfly and lavender. This main image was taken on a beautiful, clear, sunny day, shot with a 15mm f/2.8 fisheye lens and flashgun.

Using flash and underexposing the shot (−1.33 stop) is a technique I use a lot on other shoots and it works great here. The flash filled in the otherwise shadowy area of the frame to light up the butterfly, while allowing the blue sky and sun to shine through. Be careful when shooting directly into the sun. I didn't look through the camera when I took the image of the butterfly, I just held the camera down and as close as I could to the butterfly and quickly took four shots before it flew away. Knocking down my focus point a little and using a manual exposure made sure I had the best chance to get the shot right.

Narrow apertures

If you're shooting at apertures of around f/14 to f/18 for work like this, make sure that there isn't any dust on your sensor—otherwise it will show up like a golf ball! I clean my camera after every shoot, but if you're not confident of doing it yourself, send your camera to a reputable dealer to be cleaned every couple of months.

KIT LIST

→ Camera – Canon EOS-1Ds Mk III

→ Lens – Canon EF 15mm f/2.8 fisheye

→ Aperture – f/14

→ Shutter speed – 1/250sec

→ ISO – 100

→ Canon Speedlite 580 EX II flashgun

→ Other shots taken with Canon EF 70–200mm f/2.8L telephoto zoom lens

Top left > **Close-ups after the rain** is a great time to get the best details, but aim to work quietly.

Below left > Look for backlit parts of the garden, and underexpose a stop or two to retain the detail.

Right > Try moving your red autofocus point away from the center. This will mean that out of center subjects can be photographed more quickly before they fly away.

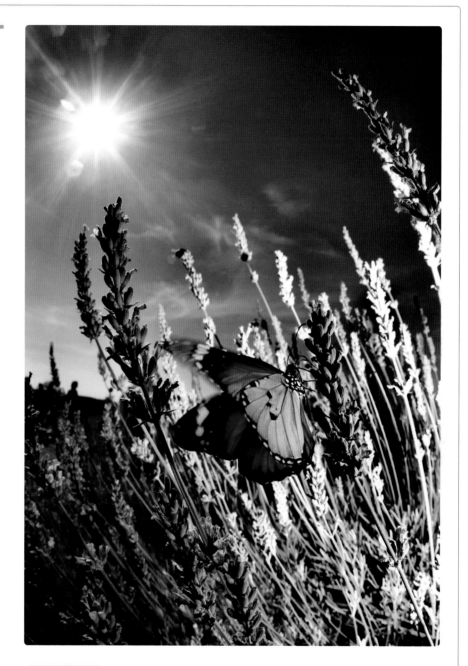

PRO TIP!

Take different lenses with you to capture all that you see. Try using a macro or telephoto lens in the garden to get close to the subject. A 100mm f/2.8 telephoto macro lens will enable you to focus closely on your miniature subjects for greater intimacy and a wonderful shallow depth of field.

ENRIQUE CUBILLO / INTERIOR PHOTOGRAPHY

INTERVIEW

Spanish-born Enrique Cubillo grew up in St. Louis, Missouri and studied at New York University. After graduating, he spent the next four years assisting some of the world's best photographers, gaining experience in all genres. A small collection of 13 images in bold colors with geometric form brought him to the attention of some major US publications. In the last six years, Enrique has been concentrating on photographing interiors. Find more on Enrique and view his portfolio at www.85photo.com

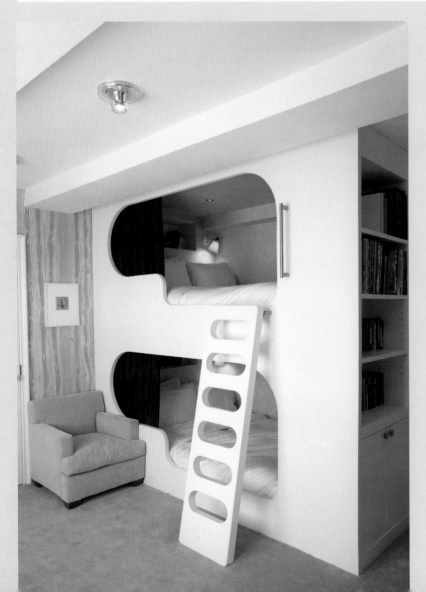

When did your interest in photography begin?

As a youngster. My father was an enthusiast and had a slide projector and a complete camera kit. When I reached adolescence, his interest waned and the gear was there for me to use. My high school had a small photography program. I began there and the interest never left me. I've been a professional photographer for 22 years.

What do you enjoy about photographing interiors?

They are like big still-life shots, which is where I began my career. It's a peaceful set that comes together slowly. I enjoy seeing what will happen with available light first. I always shoot that way prior to using lights.

How do you approach each shoot?

I am always a bit nervous and I think that is a healthy thing. Often, I'll bring some lighting equipment I may not normally bring or I'll leave something I would normally bring. This forces me to work differently all the time. I also like to make certain I've spoken at length with the client and understand their expectations, which can be very different from mine.

Above > Enrique understands the language of photography and is able to bring a keen-eye and energy to his interior shoots.

Left > As Enrique is lucky enough to be based in New York City, he's able to use the stunning cityscape as a backdrop on more elaborate interior shoots.

Do you prefer to work against a shot list or do you prefer to take control and shoot as you see the interior and conditions before you?

Either way is fine. But if I see good stuff I'll grab it, unless the client objects. No one has to date.

What skills do you think you need to make it as a good professional interiors' photographer?

The same ones that make a good product shooter. Patience. The kind of patience that allows for objects and light to speak with you and for you to answer back with a camera. It's a difficult thing to explain in words. That's the best I can explain it. Photographing people has so much of an emotional aspect to it. Interiors and product photography have a quiet language. It's a bit like contemplating the slow-moving life of a plant. There is a lot of energy and motion there—we just have to slow down and get on the same momentum. Shooting interiors is the same.

Is there anything specific you need to consider when shooting for magazines or advertising?

Vertical and horizontal use is always a concern. As far as advertising, the day's focus needs to be single minded, focused on a very particular point of view, although it may change. When it does, one has to be very aware of the directional change. Advertising needs less options. With editorial, I think a lot less about it.

What different techniques do you use to photograph interiors?

Post-production is the big thing, mostly using layers and overlays. I'll shoot multiple exposures and later patch the shot together to create stunning lighting that was either very difficult or impossible prior to inexpensive digital post-production.

Do you do much image-editing to your photos?

Yes, very much in Photoshop. It's all things that normally would have been done by a custom printer and retoucher prior to the digital age. I don't allow my photography to become illustration though. I'm not a big fan of that look.

Any top tips you can think of?

When God gives you natural light to use, by all means use it as much as possible. The bigger and heavier the tripod, the better. If you can sandbag it down all the better. Walk all four corners of a room before you shoot the final. You'd be surprised how many times I find a better angle after I just shot from the side I thought I'd favor more and I say, "why did I not just take a quick look."

ENRIQUE'S STUDIO KIT LIST

→ Canon EOS 5D Mk II cameras

→ Canon EF 16-35mm f2.8L USM

→ Canon EF 24-70mm f/2.8L USM

→ Canon EF 70-200mm f/2.8L IS USM

→ Canon EF 100mm f/2.8L Macro USM

→ Profoto strobes

→ Apple Macintosh computer

→ Adobe Photoshop

ACTION PHOTOGRAPHY

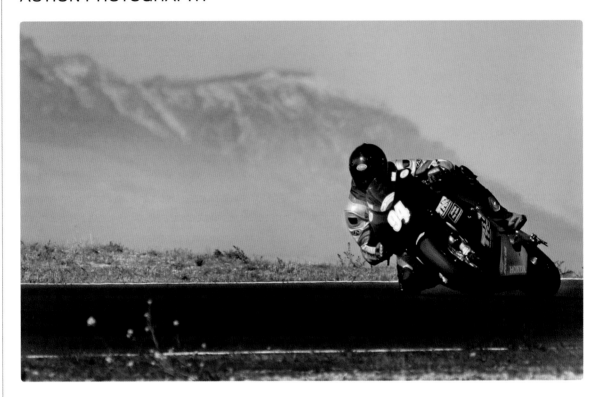

Motorbikes and cars can be hard enough to photograph when they're motionless, never mind when moving at 200mph (320km/h). Getting close to the action can produce great results, but you need to have a keen eye for the best shots.

The right shot at the right time

We received a brief from THR Racing, who were heading to Spain for preseason practice before the British Superbike season. The brief included photographing the riders in action.

I was shooting with a Canon EOS-1Ds Mk II and a meaty 400mm f/2.8 telephoto prime lens—on a monopod as the lens weight was considerable. It was a sunny day and shooting in bright conditions is perfect for action photography. With the ISO set at 400 I was able to get a fast shutter speed of 1/2000sec at f/8. Although the rider was traveling at over 160mph (255km/h), with these settings I could freeze the action and still ensure the rider and bike were both in focus.

I'd noticed that when the rider was in the corners, the bike was poorly lit. Waiting by the right corner and using the sunshine that reflected off the concrete curbs—which are usually light in color— provided me with plenty of reflected light for the rider and bike.

Above > **Create more interest in** your action images by incorporating part of the surrounding environment into your work.

Compositional considerations

I had been asked to produce an image that the client could use for their marketing campaign, which meant leaving room to one side of the rider. When the action is happening fast, sometimes your composition can suffer, so I had to make sure this was paramount in my mind. It took a couple of attempts before I got the shot I wanted. Out in the 90° heat it was tough work, but well worth it.

Carrying a radio with me was essential to keep in touch with the pit, as was a stopwatch. With over 30 riders out on the track it was important to know when our rider was about to come over the brow of the hill, otherwise there would be a lot of wasted frames of the wrong bike.

KIT LIST

→ Camera – Canon EOS-1Ds Mk II

→ Lens – Canon EF 400mm f/2.8L USM Lens

→ Aperture – f/8

→ Shutter speed – 1/2000sec

→ ISO – 400

→ Manfrotto 695CX monopod

PRO TIP!

A 400mm lens is a very expensive piece of glass. Similar shots could have been achieved with a 200mm lens and 1.6x or 2x convertor that will magnify the focal length of the lens. Some sports shooters also use non-full frame DSLRs (that is with a crop factor of 1.3x or 1.6x) to take advantage of the focal length magnification.

ACTION PHOTOGRAPHY—ON SET

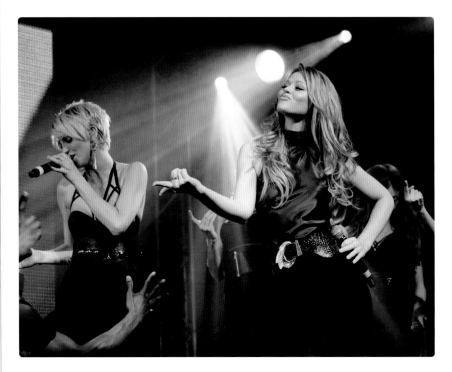

Above > Focus on individuals within the group as well as the overall stage.

Left > Make sure you know exactly when the group are coming on to stage. Times can change and you don't want to miss it.

Shooting on live sets, whether it be for film, TV, or music, can be a daunting prospect; factor in a restricted amount of time to shoot, and you have a high-pressure situation when you have to make sure you get your shots right first time.

This shoot was of the pop band Girls Aloud, who were performing for my client's private party. The atmosphere was more relaxed due to the size of the concert, but it was still a testing shoot.

PRO TIP!

At most music events you will have to shoot without flash, and as it'll be mostly low lighting, having a camera that can perform at high ISOs with minimum noise is a must.

Planning and patience

At most music performances, flash is forbidden, and this event was no exception. I had to shoot at ISO 640 to get a shutter speed of 1/100sec at f/4. I generally shoot in Manual mode at such events, fixing my exposures and waiting for the light to be what I want. This means being patient and waiting for the ever-changing stage lighting and right moment to get your shots. If there are too many front lights then you will get faces full of color all the time, so it's good to wait for a certain color or the backlights to turn in the right direction.

Work fast

At most concerts you will only get to shoot during the first two or three songs. So make the most of your time. Try and move around in the shooting pit at the front, cover the singer or group from as many angles as you can, aiming to capture their emotion.

Below left > The lights will create strange color casts—this has to be part of the shoot as you are at the mercy of the stage lights.

The more varied images you create the more you will be able to sell.

White Balance can change considerably depending on which lights are being used and what is falling on the subject. Shooting in RAW means you can quickly adjust your White Balance in Adobe Camera Raw, or any other RAW editor.

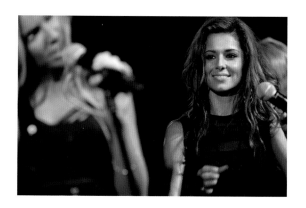

KIT LIST

→ Camera – Canon EOS-1Ds Mk III

→ Lenses – Canon EF 70-200mm f/2.8L USM

→ Canon EF 50mm f/1.2L USM

→ Canon EF 16-35mm f/2.8L

→ Canon EF 85mm f/1.2L

→ Main Shot – Aperture – f/4

→ Shutter speed – 1/100sec

→ ISO – 640

ACTION PHOTOGRAPHY—BUDGET SETUP

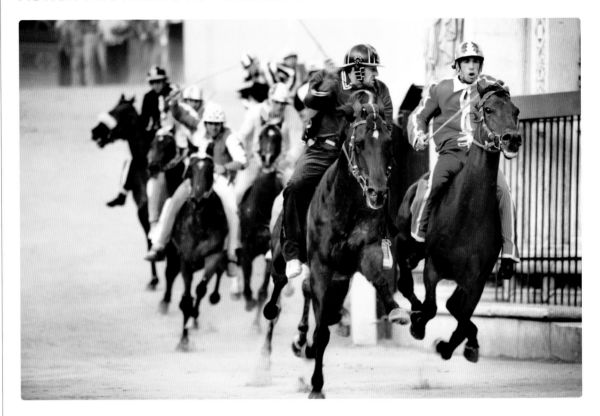

Not all action shoots are built around what's best for the photographer. Sometimes jobs can take you out into the field to photograph famous or historical events that can be over in a matter of minutes. Strategic planning and prior shot choice is what can make these unpredictable shoots a success.

KIT LIST

→ Camera – Canon EOS-1Ds Mk II

→ Lens – Canon EF 70-200mm f/2.8L lens

→ Aperture – f/3.2

→ Shutter speed – 1/250sec

→ ISO – 200

The ideal position

This action shot was taken at the historic "Il Palio" horse race in Sienna, Italy. The job was for a photography magazine and for an Italian tourist board website promoting the culture and history of Italy.

I had seen numerous shots of this famous race— during which the colorful jockeys ride bareback—and I knew that my position would be key to a successful image. We arrived at the town square eight hours before the all-too-brief, four-minute race would be taking place. Thousands of people packed out the tiny town square, which had been transformed into a 440 yard (400m) oval, dirt racetrack, but I managed to find a great spot on the home straight.

Left > Even if your photo is a one shot deal, don't panic. Know in your mind what the composition has to be before the moment happens. That way you can concentrate on aperture, shutter speed, and other settings.

Capturing the power and passion

It was important not to totally freeze the horses and riders, but to capture the power and movement as stipulated in the brief. I'd traveled with basic kit, just my Canon DSLR and two lenses. For this shot I used a 70–200mm f/2.8 lens on a full telephoto focal length of 200mm, with an exposure of 1/250sec at f/3.2. This gave me little room for focus error, but I wanted a shallow depth of field to capture the mood.

I focused on the leaders and tried to capture their spirit and passion. Using the 110 yard (100m) home straight as a backdrop gave me time to take around 15–20 shots on single shot mode. I prefer to shoot horses this way—other photographers would use continuous shooting with tracking autofocus modes to help them focus.

As I was traveling light with minimum kit, it meant I could move quickly and stay with the crowd as they carried off the winning jockey!

PRO TIP!

Try to get to the venue hours before—or even the day before—and see where the best location is and the way the sunlight falls, as the direction of the light will have a huge impact on the final shot.

ACTION PHOTOGRAPHY—PRO SETUP

It can be very difficult to capture motion in photo-shoots. Every variable has to be considered; from the power and position of your lights, if using them, to your camera settings, ambient light, the speed of the motion you're attempting to capture, and so on—there are many factors that can make or break the shoot. However, with the right planning and preparation it's possible to get great action shots.

Above > **Show the client the images as work in progress to make sure you're working along the right lines. Time is money after all.**

The best exposure

This image of Halo, a modern circus company, was shot in an underground car park. The shoot started at 8.00pm, but we decided to wait until all the ambient light from the evening sky had gone so it wouldn't interfere with our exposures. The brief was to keep the performers as still as we could while showing the extraordinary juggling skills, and their movement, as well as the light from the products.

After some test exposures we settled on the best shutter speed/aperture combination of 0.6sec at f/7.1, with the ISO quite high at ISO 500 to help project the flash lights. We used two Bron Mobilite heads for our front fill, set on 1/2 power, and Canon 580 EXII Speedlite flashguns with gels on them for our rear/rim flashes.

Stay focused

One factor that I'd not considered was that I couldn't see the performers. Even with the modeling lights it was pitch black, which meant I didn't have anything to focus on for sharp shots. Luckily I'd brought along a head flashlight. This helped me to focus on the subjects without interfering with the image.

PRO TIP!

When shooting action out on location, try to pick a location with options to shoot under cover, so if the weather is inclement you can still continue shooting. There's nothing worse than having to nervously rely on unpredictable weather when working on important shoots.

KIT LIST

→ Camera – Canon EOS-1Ds Mk III

→ Lens – Canon EF 24–70mm f/2.8L USM

→ Apertures – f/6.3–f/8

→ Shutter speeds – 0.3–0.6sec

→ ISOs – 400–500

→ Pocket Wizard Plus IIs X4 remote lighting triggers

→ 2x Broncolor Mobilite Heads

→ 2x 140x140cm Broncolor softboxes

→ 3x Canon 580EX II Speedlite flashguns

DAN MILNER / ACTION PHOTOGRAPHY

INTERVIEW

Published worldwide and scooping up awards from magazines in the USA and UK, action photographer Dan Milner has become widely recognized for adding a soulful element to images of what many people see as an inhospitable mountain environment. He has shot professionally since 1997 and is based in the French Alps. His portfolio can be seen at www.danmilner.com

How long have you been a professional photographer?

My first editorial photographs were published in 1992, but I've been a full-time professional since 1999.

What sort of action do you photograph?

I predominantly shoot snowsports and mountain biking, but previous assignments have included activities such as fell running, canyoning, and mountaineering. Essentially the mountain environment provides a common link. I can't see myself shooting weddings.

Who are your main clients?

I got started by concentrating on niche media and I'm still largely involved in shooting editorial assignments for about 20 publications around the world. I've added increasing amounts of commercial clients to my workload as recognition of my capabilities spreads.

What do you enjoy about photographing action?

It gives me the excuse to be out in big, beautiful landscapes and to visit remote corners of the world on adventurous trips—all under the guise of "work."

How do you approach each shoot?

Every shoot is different, but for all of them I make sure my gear is ready and batteries charged the night before. With on-mountain work a lot is shaped by the environment and weather as well as who and where I'm shooting. For example, a bike catalog shoot needs a different set of kit, including flashes and wide lenses, than a big mountain snow shoot in Alaska, which will use longer lenses and a lot of warm clothing.

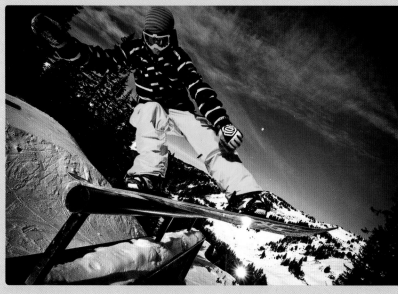

Do you approach bike shoots in the summer differently to snowboard shoots in the winter?

Snow and bike shoots are similar in many respects as both usually require you to capture an aspirational feel to the action. On snow shoots you're at the mercy of the snow conditions and you usually only get one shot at getting it right; once a track is in the shot the scene is ruined. There are safety issues to deal with too, like hypothermia and avalanche dangers! For bike shoots, you can get your model to ride and re-ride the same scene as often as you want!

If your brief stipulates a certain theme or mood, how do you prepare to fulfill it?

The words "fun" and "hero" seem to crop up pretty often in briefs for action sports shoots. Finding a model with both looks and an ability to make the action look authentic goes a long way to making a shoot successful. A bike advertising shoot stipulated "moodiness," which was achieved by a lot of fill flash to add impact via an underexposed, darkened background of the surrounding mountains. A little recon of the area as well as knowing where the sun sets can mean the difference between getting the shot and losing the next contract.

Do you prefer to work against a shot list or do you prefer to direct and shoot as you see the action unfold?

If the shoot is for a specific client's needs then I like to have a shot list to tick all the boxes. Having a little freedom to express your own style is always good though—after all, that's what gets you a name. You never know what the mountain environment has up its sleeves, so remaining flexible and patient is often the key to coming out with results. I've often got the best shots of the day and saved a shoot by being prepared to grab shots just as a beautiful break in bad weather arrives for a fleeting moment.

What skills do you think you need to make it as a good professional action photographer?

An understanding of the sport you're shooting and to realize the potential angles that make a great shot. You've got to know what story you're telling with the shot. Technical knowhow of your kit is handy but is no substitute for an eye for a stunning shot.

DAN'S KIT LIST

→ Canon EOS-1D Mk III
→ Canon EOS 5D
→ Canon 300/4L
→ Canon 70-200/2.8L
→ Canon 24-70/2.8L
→ Canon 17-35/2.8L
→ Canon 15mm/2.8 fisheye
→ Nikon 14-24/2.8G (with Nikon-Canon adaptor)
→ 2x Leica M8 digital rangefinder bodies
→ Zeiss M 28/2.8
→ Voigtlander M 12/5.6
→ Voigtlander M 15/4.5
→ Voigtlander M 40/1.4
→ Voigtlander M 75/3.5
→ Voigtlander M 90/2.8
→ 2x Canon EZ580 flash, 3x PocketWizard remote radio slaves
→ Lumedyne 400 w/s 2x head portable studio flash
→ Apple Mac Pro with Apple 24" studio display
→ Apple Mac Macbook pro 15" laptop

Far left > **Mountain sports can make for really dramatic action images.**

Left > **Dan carries a full range of pro lenses for long shots and more dynamic close-ups.**

Above > **Keeping fit allows Dan to reach locations other pros only dream about.**

SECTION 3
EQUIPMENT AND POST-PRODUCTION

3.1

PHOTOGRAPHY EQUIPMENT

→ CHOOSING MANUFACTURERS AND SUPPLIERS

→ DIGITAL SLRS

→ LENSES: ZOOMS

→ LENSES: PRIMES

→ ESSENTIAL LIGHTING EQUIPMENT

→ PRO KIT SECRETS

CHOOSING MANUFACTURERS AND SUPPLIERS

Before you invest in high-quality, professional camera equipment, you'll need to decide which manufacturer to go for. The two big brands are Canon and Nikon. They outdo each other on a regular basis as one brings out a higher-spec, pro digital SLR (single lens reflex) with the latest technology upgrades and improvements. Both are exceptional brands and make top-class cameras and high-quality lenses. However, Canon and Nikon are not the only manufacturers of digital SLRs; other manufacturers include Sony, Pentax, Samsung, and Olympus.

Once you've chosen your brand of camera, it's best to stick with it, otherwise it's a very expensive switch as, if you buy a new brand of digital SLR, you'll need to buy a new set of lenses to fit the new camera body, and that's not cheap by any standards.

Online dealers vs. street stores

The benefits of buying camera gear from an online dealer include the convenience of shopping on your computer from home, you'll have a wider choice as you have access to a global marketplace, and you're likely to get very competitive prices. The bigger web stores also provide reviews (look out for the impartial customer reviews) so you can find out what other people think of the kit you're planning to buy. However, it's a faceless and automated way of shopping, and you can't always be 100 percent sure of what you're getting.

The benefit of buying kit from your local camera dealer is that you get a personal service; you're more likely to get professional advice from true photography experts, as well as better backup service and support if your kit needs repairing or returning. You can also build a relationship with the staff in stores which can lead to discounts for multiple or consistent purchases.

You'll also be able to handle and try out gear on the spot, you'll know exactly what you're getting, and you can buy your equipment that minute, rather than waiting at home all-day for the courier to deliver your prized possessions.

PRO TIP!

Beware of online dealers who are selling equipment well below the market price, as it could be an unregistered foreign import. This will mean the camera or lens won't come with an official warranty recognized by the manufacturer should the item become faulty and you need to return it to them.

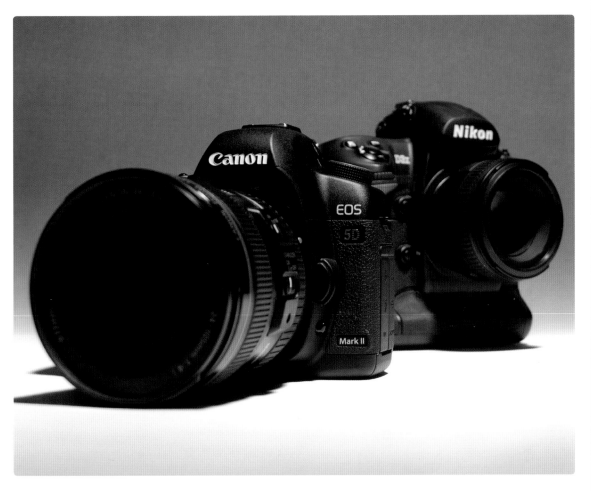

Above > At present, Canon and Nikon are the most popular brands amongst professionals, but this could change in the future.

Left > Before deciding on which kit to buy, try to test or at least hold the camera to ensure you like the way it feels.

DIGITAL SLRS

As this is the digital age we'll assume you'll be joining in and buying a professional-level digital SLR camera body and a set of professional lenses to go with it. First, the pro digital SLR.

For optimum quality, most professionals use "full-frame" digital SLRs—the equivalent sized sensor to 35mm film—as these capture cleaner images, which can be printed big without any loss of quality. In addition, if you need to drastically crop your images, the resulting smaller image will still be big enough to use and print.

Full-frame digital SLRs tend to have higher-spec sensors, providing the highest quality, and they also offer the best high ISO performance—at ISO 1600–6400 there will be minimal noise, which can potentially ruin your shots. This is where lower spec, amateur-level digital SLRs tend to fall short.

Power to the pixels
The number of megapixels tends to increase in digital SLRs every year or so, and although more pixels mean bigger images, they don't necessarily mean better images. It's the quality of the pixels that's important, and in full-frame pro digital SLRs you'll find the best-quality pixels helping to capture the most accurate and rich images—with an exceptional tonal range—whatever the subject or situation.

Pro digital SLRs with 12–16 megapixel sensors will be big enough for most professional use. But if your clients regularly request really large images/prints, then consider one of the higher resolution cameras such as the 21.1-megapixel Canon EOS-1Ds Mk III or the 24.5-megapixel Nikon D3X (or indeed the 24.6-megapixel Sony A850).

Pro SLRs also come equipped with faster image processors (some even have dual processors) to ensure your camera reads, processes, compresses, and writes image data to your memory cards without pausing and hitting the buffer. This helps to ensure you never miss a great shot opportunity, as well as recording accurate colors and white balance.

Along with bigger, sharper, and higher resolution LCDs to review your shots accurately, more responsive autofocus systems with more autofocus points, and more advanced metering systems, pro digital SLRs are also built to last. They're usually made of tough magnesium-alloy and have better dust and moisture-resistant seals to protect them from the elements. They also have more custom menus and controls to make your life easier.

PRO TIP!

If you own a medium-format camera, and you're going down the studio, product, or advertising photography route, you may want to consider buying a digital back to convert your camera into a powerful and modern digital machine. Phase One, for example, offer 20-, 40-, and a massive 60-megapixel digital backs. They're big bucks, but they produce enormous images of exceptional quality and detail.

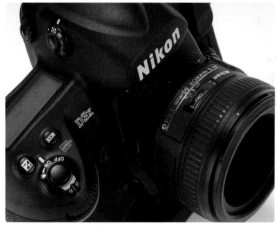

Above and left > **Modern digital SLRs**, with their full-frame, 35mm sensors, sophisticated autofocus and metering systems, and innumerable user settings are capable of capturing high-quality images of almost every photographic genre; however, some commercial clients may demand file sizes that only medium-format digital backs, such as those from PhaseOne, can offer. If needed, cost this into your quote.

LENSES: ZOOMS

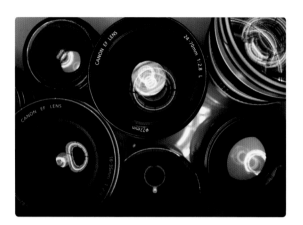

Your pro camera is only as good as your lenses, so buy the best-quality lenses you can afford. Pro-level lenses may well cost double or triple the cost of amateur lenses, but look on this outlay on expensive kit as investing in your business and career. They also tend to hold their value well.

Above > " Fast glass!" If you can afford it buy the fastest lenses you can. A fast lens is one that has a very wide aperture, such as f/2.0, which allows you to use a faster shutter speed.

Left > Long zoom lenses are a great option for unobtrusive shooting, and allow you to frame your subjects more easily.

Right and far right> Have at least a wide-angle and a zoom lens in your bag at all times. This should cover most focal lengths required.

Zoom in, zoom out

The benefit of zoom lenses, whether a wide-angle (such as 16–35mm), standard (24–70mm) or telephoto (70–200mm), is the greater choice and variation of focal lengths you have at the tips of your fingers. You can instantly zoom in to get closer to your subjects, or zoom out to fit more of your scene in the frame, all without moving. Zooming is also a good way of quickly tightening up your compositions so you have less distractions cluttering up your shots.

Wide–angle zooms

Wide-angle zoom lenses are, of course, ideal for capturing more of your subject and their surroundings in your shots—especially helpful when shooting indoors and there's no room to step back.

At very wide focal lengths (such as 16mm) you can exaggerate your subject's shape, but this distortion might not be to everyone's taste. Wide-angle lenses also naturally capture a greater depth of field. This is helpful when shooting interiors or gardens when you want the entire scene in focus.

Telephoto zooms

Whatever subject you're shooting, a high-spec telephoto zoom is an essential lens for every professional photographer. It enables you to fill the frame for tighter, more intimate compositions. As telephoto zooms capture a shallower depth of field, they're ideal for portrait and product photography when you really want to knock the background well out-of-focus to help your subjects stand out from their surroundings.

Telephotos also compress perspective, which can be helpful when you want to pull elements in your shots closer together, such as rows of trees in a garden or plates of food lined up on a table. They're also perfect for when you want to zoom in and isolate the most interesting and exciting part within a scene.

PRO TIP!

If your camera isn't full-frame, bear in mind the EFL (effective focal length) of your lenses. If you have a digital SLR with an APS-C-sized sensor you'll experience a crop factor of 1.6x; this results, for example, with a 24–70mm lens having an EFL of 38–112mm. Crop sensor cameras can be useful for sports and action shots when you want to get closer to your subjects (a 200mm focal length has an EFL of 320mm), however, it can be a hindrance at wide-angle ends when you're tight on space and a 17mm focal length (EFL 27mm) isn't wide enough to fit everything into your frame.

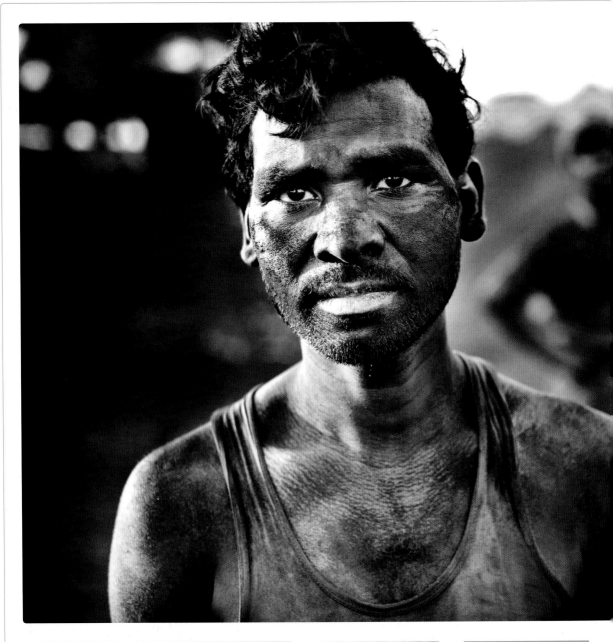

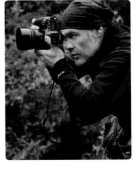

Above > Fast primes are expensive but worth every penny. Shooting wide open at f/1.2–1.8, with such a narrow depth of field can be tricky, so make sure you stay very still!

Left > Prime lenses are great for fashion, travel, and documentary photography, and are perfect for carrying around when the terrain gets tough.

LENSES: PRIMES

Prime lenses are those with a fixed focal length, such as 50mm, 85mm, or 300mm. Such lenses are generally considered to have superior optical quality because they have fewer moving parts compared with zooms, which can compromise overall image quality. This is why primes are popular with pros as, used correctly, they ensure the highest-quality image results.

Primes are wonderfully simple to use, but if you're used to shooting with a zoom, it may take you a while to become comfortable with just a fixed focal length with which to frame your shots. However, prime lenses are good for improving your photography as they will make you think and work harder with your compositions—and bear in mind you can always "zoom with your feet" by physically moving closer or farther back from your subjects to fit more or less in your frame.

Prime time

A very popular lens with true professionals is the 50mm "standard" prime lens—sometimes referred to as the "nifty fifty." These are lightweight and relatively inexpensive, standard focal length lenses, which, for the price, offer exceptional image quality. Most "nifty fifties" have a maximum aperture of f/1.8, which offers good low-light performance and narrow depth of field for selective focusing.

But there are a number of 50mm lenses on the market with even greater apertures. The wider the aperture, the better the optics (and higher the price), but a high-end 50mm f/1.2 or f/1.4 lens can be a valuable weapon to have in your photographic arsenal. With such a wide aperture you'll be able to shoot effectively in very low light without the need for flash, producing wonderfully warm, natural results.

PRO TIP!

Higher-spec prime lenses are more robust and will cope better with continuous daily use. They capture consistently sharper shots at all apertures and focal lengths, their autofocus will be faster, quieter, and more accurate, and they also usually have a "faster" constant aperture (such as f/2.8) to help with creative use of depth of field and to ensure sharp results whatever the lighting conditions.

ESSENTIAL LIGHTING EQUIPMENT

Whatever your subject, and whether you work on location or in studios, you'll need a set of lights. Lights allow you to be the boss of your lighting whatever the situation, and that means well-lit, creative, and consistently professional results for your clients.

Lighting kits with two or three flash heads are a good starting point. Kits usually come with a selection of diffusers (such as umbrellas and softboxes) to attach to your flash heads to soften and direct your light. Kits should also include stands, power leads, and sync leads to connect your digital SLR.

Lighting power

The power of your lights will depend on your subjects and your budget, but usually a 400Ws (watt-seconds) is powerful enough for most applications. Look for lights that can be manually adjusted with around five stops of adjustment, from full power to 1/32nd of full power. A modeling light is also helpful when setting up your lights and positioning your subject.

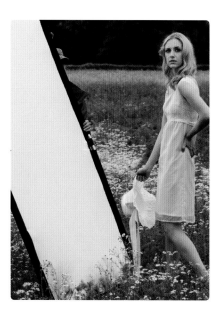

Above > Experiment by using your lights at different angles. You never know what lighting effect may result.

Far left > Large reflectors such as this are perfect for throwing maximum ambient light back onto the subject.

Left > An assistant is invaluable when there are many lights to set up and position.

Right > For maximum benefit, choose a portable lighting kit that you can use both in and out of the studio, such the Elenchrom Quadra kit shown here.

Lightweight lights and sunlight

If you're working a long way from any electrical points, you'll need battery-powered lights. They're portable, powerful, and robust, enabling you to set up your lights wherever you are to capture professional-looking portraits.

If it's sunny and there's no shelter, embrace the sunlight and use it as a secondary light source in tandem with your lights; either directly or use a (collapsible) reflector to bounce light into your subjects' faces to avoid unsightly shadows. A good technique when shooting toward bright daylight is to add some "fill light"—with a flashgun or lighting head —to avoid underexposed subjects.

PRO TIP!

If you're on a budget or not ready to make the jump to a full studio lighting kit, why not buy two decent flashguns (strobes) instead? Buy some flashgun diffusers (try Sto-Fen Omni Bounces and Gary Fong Lightspheres) and stands and you'll be able to still take well-lit, creative, and professional-looking photos. A Lastolite EzyBox on your flashgun is also a great way to bring softbox softness to your shoot, whether on location or in the studio.

← 148
→ 149

PRO KIT SECRETS

Your photographic equipment should be there to make your life easier. There are lots of clever gizmos and gadgets available today to help you take better photos, and to work more efficiently, but the main essentials are listed below.

Essential gadgets

It's worth investing in some decent wireless radio flash triggers. Being tethered to your lights can be very restrictive when moving around with your camera, trying to take photos of your subject from different angles. Wireless radio flash triggers give you much more freedom, which means you can work faster, and ultimately you'll produce better, more creative results. Simply attach the transmitter to your camera, and the receiver to your light head or flashgun, which can be positioned hundreds of feet away—some, such as the Pocket Wizard are active up to 1,600 feet (500 meters)—to give you more options with your shots.

Another pro essential are camera filters. Every self-respecting pro carries a set of Neutral Density (ND) filters and ND Graduated filters; the former enabled you to use slow shutter speeds to capture movement in your shots in bright light, the latter allows you to enhance drab skies, whether shooting people, products, or gardens. A circular polarizing filter is also useful when photographing in bright sunshine and you want to boost the color contrast of your skies—or to reduce reflections on objects or the surfaces of water.

Top > Radio triggers offer the benefit of wireless shooting over long distances, giving you more freedom when shooting.

Below > Every camera bag should have a set of appropriate filters for the job in hand—they help to control natural lighting conditions.

Left > Portable hard drives such as the Epson P5000 are perfect for backing up images on the job, and for a quick review of shots.

Below left > "Portfolio on the go." You never know when you may meet your next potential client. Always have your best shots to hand.

Working on the move

The life of the professional photographer can be nomadic, so it's good to have a large-screen laptop so you can work on location, downloading, checking, and processing shots, and to be online to stay in contact with clients and jobs. Carry a few recordable compact discs as you may need to burn images straight after a shoot for a client with a pressing deadline. A portable hard drive is also worth carrying around for backing up your valuable shots.

A decent cell phone is essential; to make calls, check emails, stay in contact with your clients, as well as working as a GPS unit for finding locations, and a device for viewing your shots or quickly displaying your portfolio to prospective clients.

Always carry spare camera and flashgun batteries, several empty memory cards, a memory card reader, a sensor cleaning kit, and your passport as you never know when you might be traveling abroad.

CHECKLIST

→ Choose your camera brand

→ Pick your pro digital SLR

→ Invest in a set of professional zoom lenses

→ Consider buying prime lenses

→ Select a good set of studio lights and diffusers

→ Don't forget the essential kit too

3.2

POST-PRODUCTION

PHOTOSHOP INTRODUCTION

As well as being able to take professional-standard photographs, you also need to be able to process your images professionally. Building up your Photoshop skills can take time, so to help build your confidence and get you started off on the right foot, in this chapter we show you key Photoshop image-editing techniques.

Before you begin post-production and start to enhance your images, it's important to remember the golden rule: only use Photoshop to turn a good image into a great image, not to try to transform bad into good.

We'll begin with the basics using cropping, Levels to boost contrast, and sharpening to quickly improve your images. We then show you professional techniques to process RAW files for the best results.

Following on from Chapter 2.3, we reveal tried-and-trusted methods for processing your food, people, product, garden, interiors, and action images—while covering essential Photoshop techniques, from color correction to adjustment layers, Curves to cloning, and selective tonal enhancements to smart sharpening.

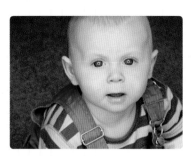

Photoshop basics. See page 154.

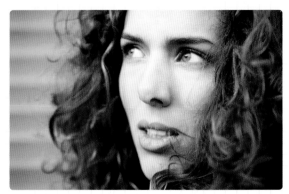

RAW processing. See page 156.

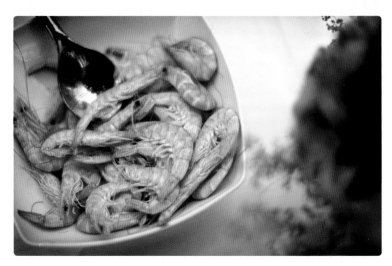

Photoshop guide—food photography. See page 160.

Photoshop guide—people photography. See page 164.

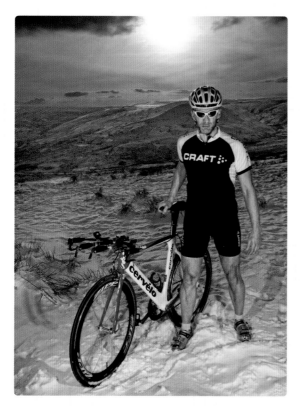

Photoshop guide—product photography. See page 168.

We reveal pro secrets for batch processing multiple RAW shots, how to create contact sheets, as well as advanced techniques for enhancing your shots, and how to present your images in a triptych format.

We round things up by explaining how to prepare images for editorial and advertising use and the importance of archiving and backing up your images for long-term storage.

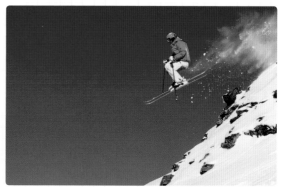

Photoshop guide—action photography. See page 176.

Photoshop guide—advanced techniques. See page 180.

Photoshop guide—garden photography. See page 172.

PHOTOSHOP BASICS

Before and after images: Peter Travers
Canon EOS-1D Mk III
Canon EF 24–70mm f/2.8L USM
Exposure 1/400 sec at f/5.6; ISO 800

How much time you spend processing your images using software such as Photoshop, is partly down to preference and your photographic style, and partly down to the results your client is expecting. Either way, it's important to have some effective Photoshop image-editing techniques in your repertoire for quickly polishing images to send on to clients.

A quick yet tried-and-tested technique favored by many pros for enhancing images involves using three main Photoshop tools—the Crop tool, the Levels dialog, and the Unsharp Mask filter. Although it's always best to get it right in camera, cropping in Photoshop is a quick way to improve composition, using Levels will boost contrast for added impact, while sharpening helps clean-up edge details and prepares images for printing.

STEP 1 Open your image in Photoshop, and select the Crop tool from the Tool palette. Click the Front Image button in the Tool Options bar if you want to retain the image's aspect ratio. The trick to cropping is learning which elements to leave in and which to exclude to improve composition. Drag the mouse to set your crop area, and move it with the Move tool until you're happy with the position. If you are using Photoshop CS5, choose Rule Of Thirds from the Crop Guide Overlay drop-down menu to help improve the composition. When done, click the tick in the Tool Options bar to commit the change.

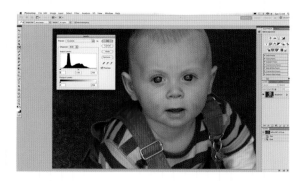

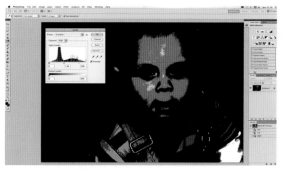

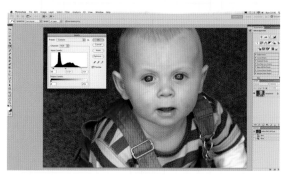

STEP 3 When making adjustments using Levels, be careful not to create any unwanted "clipped" tones. When shadows are clipped, the pixels will be totally black with no detail. When highlights are clipped, the pixels are a detail-free white. To check, when moving the White or Black Point slider, hold down the Alt/ Option key; any clipped highlights or shadows areas will appear red and yellow on your image.

STEP 2 Now go to Image > Adjustments > Levels to open the Levels dialog box. To enhance contrast, lighten the highlight tones by moving the White Point slider to the right edge of the histogram, and darken the shadow tones by moving the Black Point slider in to the left edge of the histogram. If necessary, you can also adjust the mid-tones by moving the middle input slider. Move this to the left to lighten the image or to the right to darken it.

STEP 4 Next, go to Filter > Sharpen > Unsharp Mask for full control over the sharpening of your image. The Unsharp Mask works by simply increasing contrast along the edges of the image. It's crucial to sharpen subtly: if you oversharpen you'll end up with halos and ugly results. As a guide, keep Amount to between 70–150 percent, Radius between 1.0–2.0 pixels, and Threshold left at 0. To avoid introducing unwanted noise, try experimenting with Threshold values between 2 and 20. Click OK and save the image.

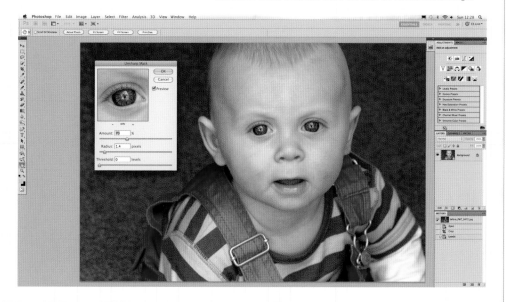

← 156
→ 157

RAW PROCESSING

RAW is the highest quality image setting. Most pros choose to shoot RAW almost exclusively as it gives them greater control when processing their images. Like digital negatives, RAW files contain the maximum amount of picture data.

Because RAW files contain unprocessed picture information, you have to process RAW images to obtain TIFF or JPEG files that you can then print or upload to a website. Adobe's Camera Raw editor (part of Photoshop) is perfect for processing RAW files quickly and effectively. When you make modifications to RAW images, the original data is preserved (so you can always revert back), and the adjustments are stored for each image as metadata embedded in a "sidecar" .XMP file.

The following example shows an overview of Adobe's Camera Raw editor to help you process your RAW files.

Before and after images: Peter Travers
Camera: Canon EOS-1D Mk III
Lens: Canon EF 85mm f/1.2L II USM
Exposure: 1/320 sec at f/2.8; ISO 100

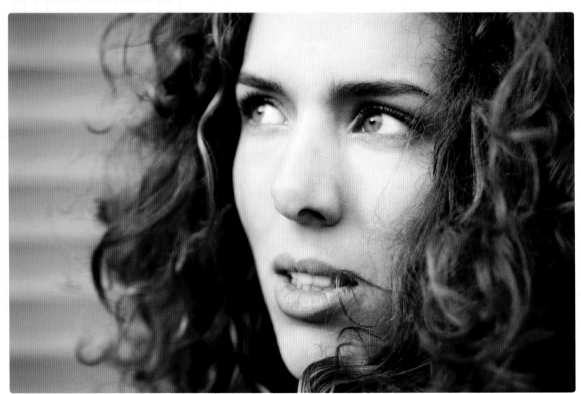

STEP 1 Open your RAW file in Photoshop and it will open the Camera Raw workspace. First, you can adjust the White Balance (WB) from 2000–50,000K to correct any color cast by cooling down or warming up your image. This is a very accurate way to adjust White Balance. To cool your image down or make it bluer, drag the slider toward 4000K and below; to warm it up or make it redder, aim for 5500K and above. You can also use the presets such as Cloudy, Flash, and Tungsten in the pull-down menu.

STEP 2 In the top right corner is your image's histogram with the overall tones shown in white, and also the tones in the red, green, and blue (RGB) channels. Click on the two arrows above the histogram to switch on the Highlight and Shadow clipping warnings. Any clipped highlights will appear in red and clipped shadows will appear in blue.

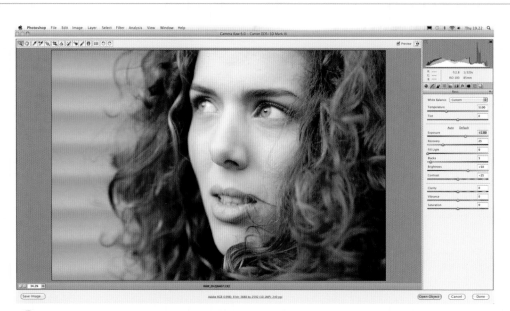

STEP 3 The Exposure slider is an excellent way to correct your exposure. You can increase (brighten) or decrease (darken) your exposure in equivalent f-stop increments (up to +/− 4 stops). If you start to clip any highlights when brightening images, drag the Recovery slider until the red clipped warning disappears.

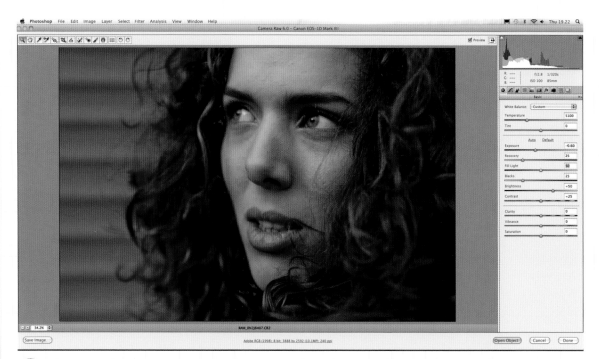

STEP 4 If you're darkening your exposures with the Exposure slider or darkening the shadows with the Blacks slider, and you start to clip any shadows in darker areas of your image, use the Fill Light slider to recover detail and brighten up the shadows without brightening the black tones.

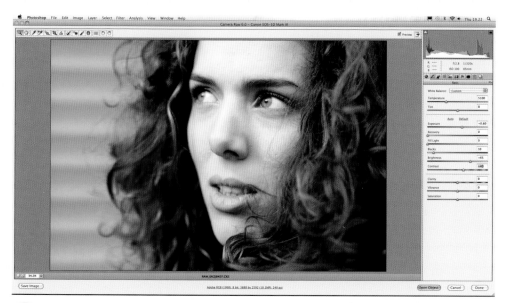

STEP 5 To brighten the mid-tones, without touching the shadows or highlights, you can use the Brightness slider. If you need to boost the overall contrast of the mid-tones, without affecting the shadows or highlights, you can use the Contrast slider. Work within the +35 to +75 parameters for the most realistic results. You may need to readjust the Exposure and Recovery sliders after doing this.

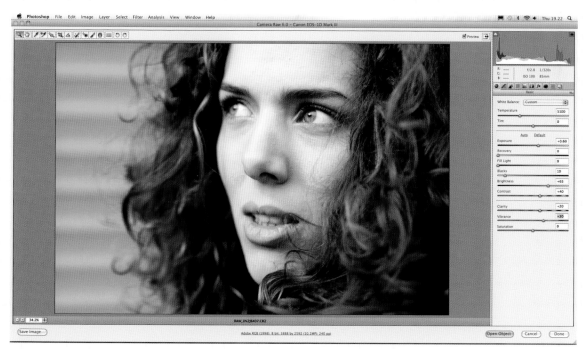

STEP 6. The Clarity slider is helpful for an initial sharpen; it increases local contrast, concentrating on the mid-tones, and works rather like a large-radius Unsharp Mask. To enhance the colors of your RAW file, you can use the Saturation slider; although the Vibrance slider offers greater accuracy, plus clipping is minimized when colors approach full saturation. As with most image-editing tasks, subtle enhancements produce the most realistic results.

← 160
→ 161

PHOTOSHOP GUIDE—FOOD PHOTOGRAPHY

Photoshop is an essential tool for working on images accurately and professionally, and most of the time it will fulfil your post-production needs. However, there are also many software plug-ins available on the market that will make editing quicker for certain effects—after all, the less time spent working on images the more time you can be shooting.

Plug-ins are small programs that work to extend the capabilities of a larger program. A plug-in I use a lot within Photoshop is Nik Software's Color Efex Pro. Using Color Efex Pro enables me to work quickly in mid-tones, highlights, and shadows separately. In this example, I wanted to enhance the shrimp and bring out their texture while leaving the rest of the shot untouched.

Before and after images: Brett Harkness
Canon EOS-1Ds Mk III
Canon EF 50mm f/1.2L USM
Exposure 1/5000 sec at f/1.2; ISO 100

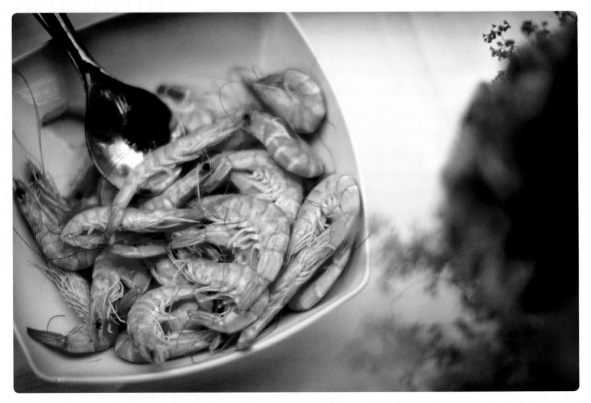

 STEP 1 First download and install the Color Efex Pro plug-in (free trial available from www.niksoftware.com).

Launch your version of Photoshop or Photoshop Elements, and go to Filter > Nik Software > Color Efex Pro.

STEP 2 Opening up the image in Color Efex Pro, select Remove Color Cast from the left-hand menu. This image was shot in JPEG and because of the settings they all had a slight

red color cast. I prefer my images to usually be slightly cold (blue) so I can warm them up a little, but in this case it's the other way around.

![STEP 3 arrow icon] **STEP 3** Click OK. Back in Photoshop, you'll notice Color Efex Pro has created a new layer with the enhancements. I now wanted to selectively adjust the shrimps in the dish, so I used the

Lasso tool to draw around and select the shrimps. Right-click and select Feather, and set Feather Radius to around 7 pixels.

![STEP 4 arrow icon] **STEP 4** Again, I went to Filter > Nik Software > Color Efex Pro to open just the shrimp selection. The Tonal Contrast control in the left-hand menu allowed me to work on the highlights,

shadows, and mid-tones in turn. Use the sliders to set High Contrast to around +50, Midtone Contrast to around +13, Shadow Contrast to around –2, and Saturation to around +35.

STEP 5 Go to Select > Deselect to deselect the shrimps. Now go to Filter > Nik Software > Color Efex Pro to open up the whole image in Color Efex Pro. This time I used Pro Contrast from the left-hand menu, setting the Correct Color Cast slider to 30 percent and Correct Contrast to 70 percent to tweak the contrast and get rid of any color cast that may still have been there.

STEP 6: Finally in Photoshop, I used the Burn tool to darken parts of the image. I like adding a slight vignette to my images as it concentrates the viewer to the focal point of the shot. Use a brush size of around 500–700 pixels, keeping range on Midtones and Exposure at around 15 percent—it's best to build up slowly when burning. Go to File > Save As, choosing the Photoshop format if you wish to retain the layers, or JPEG if not.

PHOTOSHOP GUIDE—PEOPLE PHOTOGRAPHY

← 164
→ 165

Before and after images: Brett Harkness
Canon EOS-1Ds Mk III
Canon EF 50mm f/1.2L USM
Exposure 1/200 sec at f/16; ISO 100

When processing portrait images it's crucial to be subtle with your retouching. You want to edit and enhance in the same the way you lit and photographed the subject—not change the way they look. Sometimes you may need to remove skin blemishes, stray hairs across the face, and any slight bags under the eyes.

Retouching portraits for high fashion is big business—which is why "Photoshopping" has become a by-word for retouching images of people. For this portrait we're going to use Photoshop to clean up the skin a little and produce a smooth, tonal black-and-white conversion for a front cover of a magazine.

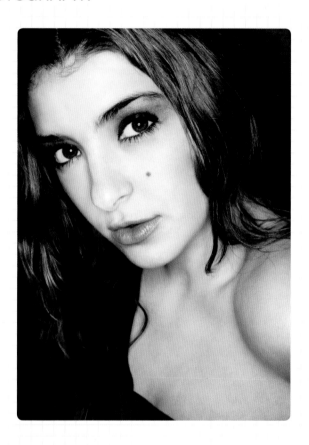

STEP 1. Open your image in Photoshop and go to Layer > New Adjustment Layer > Curves. I regularly alter Curves throughout the processing of images so it's best to keep it as a separate layer. That way I can come back to it if necessary. For portraits, I usually raise the middle Curves to increase overall tonal brightness.

STEP 2. To clean up the face and remove stray hairs and unwanted bags under the eyes, duplicate your original Background layer (Layer > Duplicate Layer). Call this layer "Hair." Using the Patch tool or Spot Healing Brush tool (or a mixture of the two) carefully remove any skin blemishes and hairs across the model's nose and over the left eyebrow. As this is a separate layer you can reduce the Opacity (on top of the Layers palette) to fine-tune the amount of retouching.

STEP 3 It's always important to check the color of your images. This can be done in many ways. I prefer to check and adjust the color by eye using Color Balance (Image > Adjustments > Color Balance) or Selective Color (Image > Adjustments > Selective Color). This way I can tweak selective color channels or get rid of color casts as necessary.

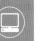

← 166
→ 167

STEP 4 There are a number of ways to convert an image to black and white, including; Grayscale, Black & White, Desaturate, Gradient Map, and Channel Mixer. I'm going to do it the easy way, which also gives me the greatest control over the conversion. Go to Image > Adjustments > Black & White for a starting base layer. Click OK. Then use the Dodge and Burn tools to lightly dodge over any areas that are too dark, and burn in any areas that are too bright—this provides an overall even tone.

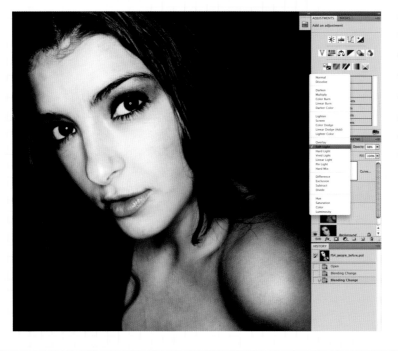

STEP 5 Our aim now is to create a punchy black-and-white image with all the tones from white/gray to black. Duplicate the layer again and go to the Layers palette and choose Soft Light from the Blending Mode drop-down menu. Use the Opacity slider to reduce the effect. This image has had 88 percent Soft Light added to it.

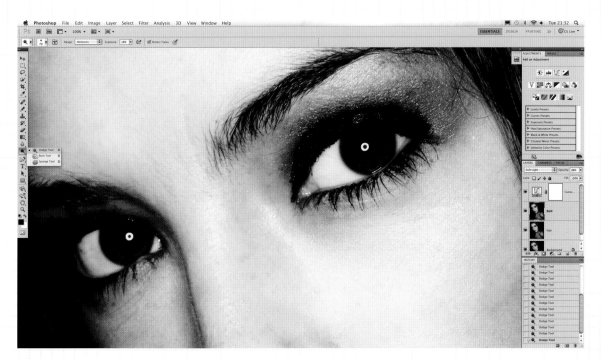

STEP 6 For portraits, it's important to emphasize the eyes. Again, this can be done in many ways; you can select the area with the Lasso tool and use Curves or Levels to raise the brightness of the selected area. I prefer to work on a duplicate layer and emphasize the eyes with the trusty Dodge and Burn tools. Using a soft-edged, small brush (around 50 pixels), with Range set to Midtones, and Exposure to around 15 percent, I work my way around the eyes, dodging the whites and irises to brighten them up, and burning in the pupils to darken them a little.

STEP 7 Final steps include meticulously checking for dust spots, zoomed in at 100 percent, using the Spot Healing Brush tool to remove any as I go. I also crop now if necessary. Usually, I shoot full-frame so no cropping is needed but sometimes the client demands a specific size. This image is cropped at 12 x 10in (30 x 24cm) using the Crop tool. At this stage I also adjust the contrast by going to Image > Adjustments > Brightness/Contrast. The last thing I do is sharpen with Filter > Sharpen > Smart Sharpen. Depending upon the amount of sharpening required settings can differ, but usually I sharpen around 0.7 pixels at 50–70 percent Radius.

← 168
→ 169

PHOTOSHOP GUIDE—PRODUCT PHOTOGRAPHY

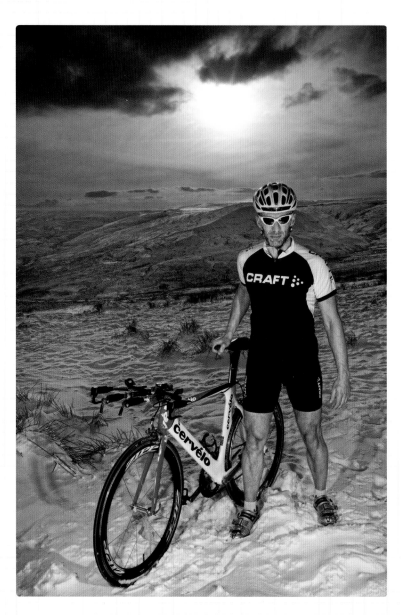

Before and after images: Brett Harkness
Camera: Canon EOS-1Ds Mk III
Lens: Canon EF 24-70mm f/2.8L USM
Exposure: 1/250 sec at f/20; ISO 200

Our profession can take us to some amazing places and push our camera and lighting equipment to photographic extremes. When photographing products, we usually shoot them in the comfort and warmth of the studio, but it's becoming increasingly popular to shoot products in a lifestyle setting. In such extreme conditions, as the finished example here shows, some subtle but necessary Photoshop improvements are required to make the scene, product, and model all look their best.

STEP 1 With this particular shot, the first step was to replace the overly bright sky. On the original image it was impossible to capture detail in the sky with the strong afternoon sun while exposing for the rider and bike in the foreground. So I took a second shot exposing for the background scene. Using the Quick Selection tool on the sky frame, I carefully drew along the horizon to select the sky, zooming in to neaten up the selection along the horizon. Hold down the Alt key if you need to subtract from your selection.

STEP 2 I used Ctrl/Cmd+C to copy and move the new sky to the original image, and Ctrl/Cmd+V to paste it on top as a new layer. Use the Move tool to reposition if necessary. To tidy up the join, click the Add Layer Mask icon at the bottom of the Layers palette. Choose the Brush tool, set size to around 300 pixels, Mode to Normal, and Opacity and Flow to 40 percent. Press D to default your Foreground/Background colors to white/black, then press X to set Foreground color to white. With the mask selected, paint along the horizon to blend the new sky with the original shot.

← 170
→ 171

STEP 3 To merge the sky with the original image, I needed to adjust the colors and tones. To tweak the colors so the new sky fits with the original shot, I used Color Balance (Image > Adjustments > Color Balance) to cool down the sky, adding a little more cyan and blue. If you need to bring out the detail in the mid-tones and to subtly soften highlights, you can use Curves or Levels. But don't apply too much tonal contrast or the image will start to look too grainy and unrealistic. If needed you can reduce the opacity of your new sky with the Opacity slider.

STEP 4 Shooting at narrow apertures of between f/16–f/22 will show up dust on your camera's sensor more than with wider apertures. Although your DSLR's sensor may have been cleaned before the shoot, changing lenses on location can allow dust in. To remove the dust, use the Spot Healing Brush (make sure you untick Sample All Layers) or Clone tools to clean up the sky. Zoom in at 100 percent view, use a brush size of around 50 pixels, and work around the image to clean it up.

STEP 5 I was now able to selectively dodge and burn different areas of the image to bring out the hills in the background and the bike and rider. I like to add depth to my images by using the Dodge and Burn tools in this way. It's replicating traditional darkroom techniques, and we used to do this when hand printing with negatives in the good old days! Ensuring the Background layer is selected, I dodged the rider's face to lighten it.

STEP 6 Now to concentrate on the product. It's important the product's colors and tones are accurate. I used the Burn tool to darken the blacks, using a small soft brush, with Mode set to Midtones and Exposure to around 20 percent to build up blacks subtly. Making sure the black parts—tires, handle bars, and logo—were made darker gave the product depth, and drew emphasis to the all-important bike.

STEP 7 Finally, I flattened the image (Layer > Flatten Image) so the new sky and original image were on one layer. To add some overall punch to the entire finished image, I went to Layer > Duplicate Layer, then with the Duplicate Layer selected, I chose Soft Light from the Blending Mode drop-down menu. Following some smart sharpening, the finished print was ready.

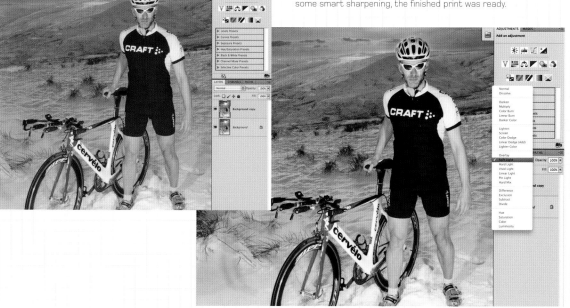

← 172
→ 173

PHOTOSHOP GUIDE—GARDEN PHOTOGRAPHY

In plant and garden photography, you'll often need to give nature a helping hand and boost the colors and saturation so your images look bright and colorful in print. Here we'll show you the best way to selectively enhance the colors of individual parts of your shots.

Also covered are accurate techniques to remove unwanted artifacts and stray shoots, leaves, or branches, how to increase the contrast for more striking results, and pro techniques for sharpening your images.

Before and after images:
Peter Travers
Canon EOS-1D Mk III
Sigma 105mm f/2.8 EX DG
Exposure 1/200 sec at f/4; ISO 160

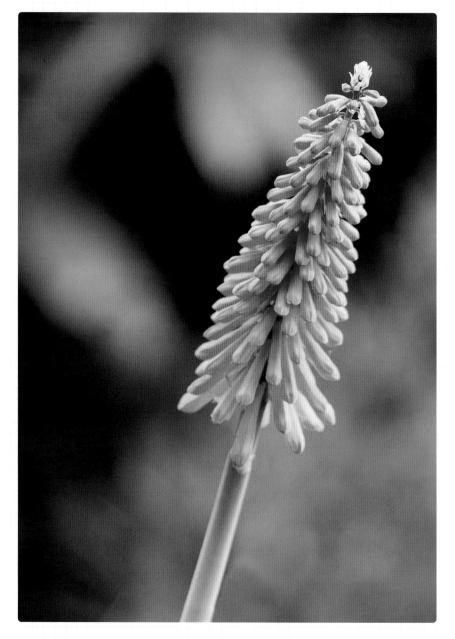

STEP 1 I started with a RAW image for this Photoshop CS guide, so I opened the image in Adobe's Camera Raw editor. First, I cropped the image, using a 3:4 ratio, and tilted the crop for a more dramatic result. To reduce the highlights on the outer petals I nudged the Recovery slider up to 20. I then clicked on Open Image to open the photo in the full Photoshop workspace.

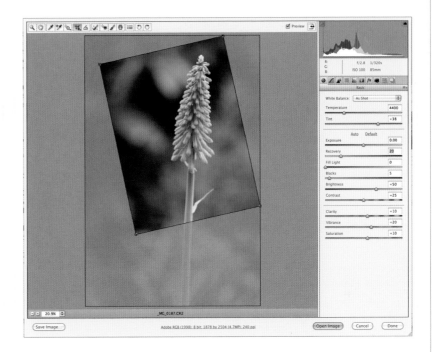

STEP 2 In botanical shots, there are often distracting parts of plants sticking out. To remove the stray shoots on the stalk, zoom in (Ctrl/Cmd and "+"), then select the Clone tool from Tool palette. Choose a 250–150-pixel brush, set Mode to Normal, and Opacity and Flow to around 70 percent. Hold down the Alt/Option key and click on a clean area of background to clone, then click and paint over the area you want to remove.

← 174
→ 175

STEP 3 Make sure you always clone an area as close as possible to the area or object you want to remove for the most accurate and realistic results. Each time you click the mouse you're painting over the area with another layer of cloned material. As you get closer to the object, drop the brush size down to around 50–100 pixels, and go carefully on the edge of it. If you make a mistake, click back on the History palette, and have another go.

STEP 4 To boost the colors and contrast, I created a Curves adjustment layer (Layer > New Adjustment Layer > Curves). By creating an adjustment layer I can return to this layer at any time to make further adjustments. I've created a classic S-curve to increase the contrast by brightening the highlights and darkening the shadow, with more emphasis at the top of the curve to brighten the lighter areas.

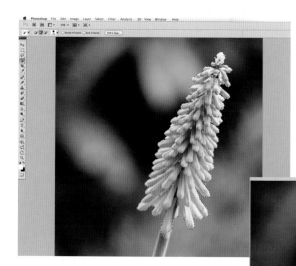

STEP 5 With flower photos you may need to further enhance the colors of elements like the flower heads and petals. For this use the Quick Selection tool, with a brush size of around 100 pixels for an accurate selection, and brush over the petals. Right-click on your selection and set Feather to around 8–10 pixels. Go to Layer > New Adjustment Layer > Hue/Saturation, and set Saturation to around +20 to realistically boost the flower's colors.

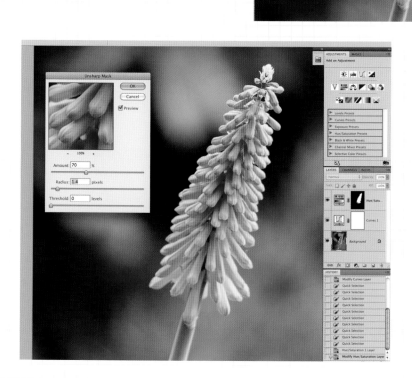

STEP 6 It's good practice to leave sharpening until you've finished all your other adjustments—if you do it earlier in the sequence, edits after sharpening can reduce the quality of the image. Select the Background layer in the Layers palette, and go to Filter > Sharpen > Unsharp Mask. Using the preview window as a guide, I find these settings work well: Amount to 70 percent, Radius 1.4 pixels, and Threshold left at 0. Click OK. Go to File > Save As, and choose the Photoshop format (.psd) if you wish to return to the image at a later date, or JPEG if going to straight to print.

← 176
→ 177

PHOTOSHOP GUIDE—ACTION PHOTOGRAPHY

When processing images, always consider your client's needs. It's likely they've picked you for your photographic style, but double-check on the look they want before going to work in Photoshop.

If you're supplying images for editorial or advertising use, bear in mind the aspect ratio when cropping your images, and whether or not you need to leave empty space within your images for the client to add text. It's also important to know if the image will be used across a double-page spread—if your subject is positioned in the middle it may get lost in the "gutter."

Before and after images: Peter Travers
Camera: Canon EOS-1D Mk III
Lens: Canon EF 24-70mm f/2.8L
Exposure: 1/1000 sec at f/8; ISO 200

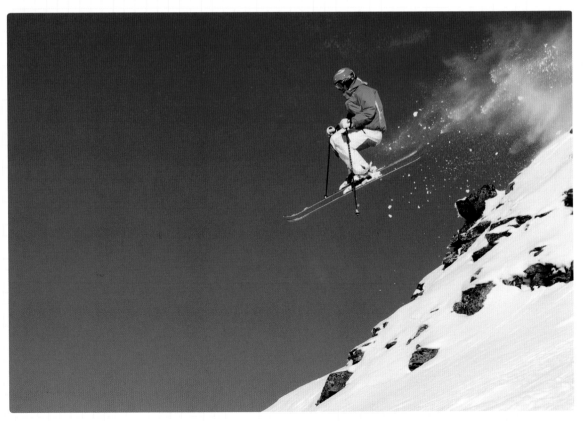

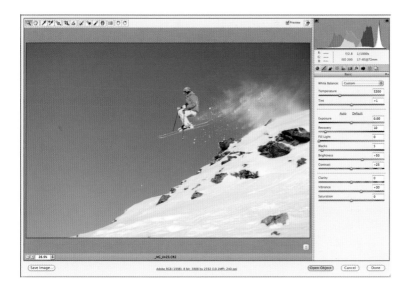

STEP 1 I'm starting with a RAW image for this Photoshop CS guide, so I opened this shot of a skier in action in Adobe's Camera Raw editor. Shooting action sports in the snow can prove tricky as all the white snow will make your camera underexpose the shot. Drag the Exposure slider to the right to brighten your image and the whites if necessary.

STEP 2 It's always important to ensure the whites in your image are actually white. The Temperature slider in the Camera Raw editor is a very accurate way to adjust White Balance. Here I dragged the Temperature down slightly to 5200K to maintain the cold feel of the snowy location. To warm up your images, increase the Temperature to 6000–7000K.

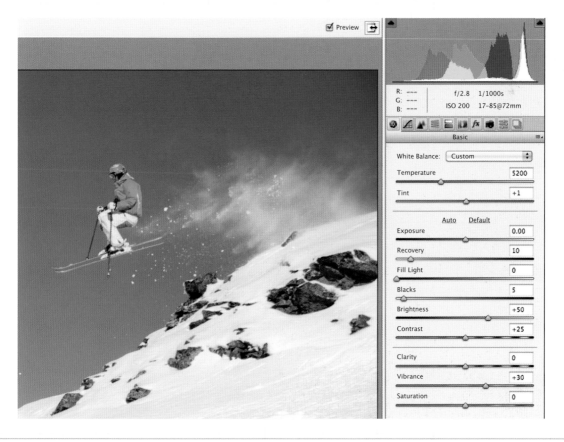

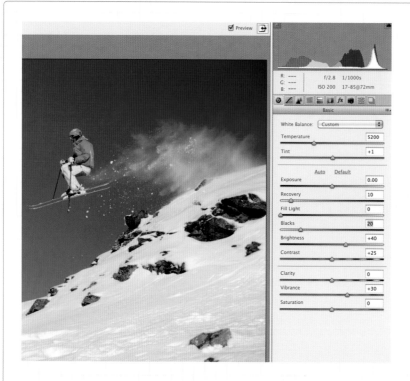

STEP 3 If any of the white areas of your images are clipped (overexposed), use the Recovery slider to reduce their brightness. I nudged Recovery up to 10 for this shot. I also boosted the contrast and colors in Camera Raw by moving the Blacks slider up to 20, reducing Brightness to +40, and increasing Vibrance to around +30—any higher settings and the image would start to look unrealistic. Now click on Open Image to open it in the full Photoshop workspace.

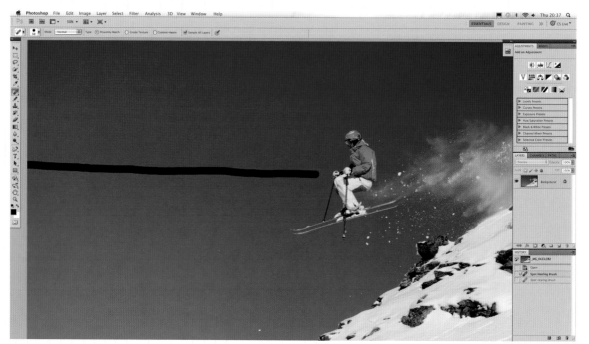

STEP 4. When shooting action subjects with big expanses of sky, unwanted power cables can often find their way into the shot. The quickest and best way to remove them is to use Photoshop's Spot Healing Brush tool. Zoom in a little, set a brush size of around 70–100 pixels and paint over the areas you wish to remove. If cables are across a mixture of background elements, click the Content-Aware box (available in CS5) and let Photoshop automatically remove the cables. If you make a mistake, click on the History palette to go back a stage and try again.

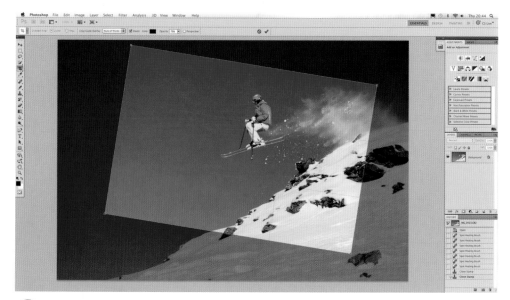

STEP 5 Adding a "Dutch tilt" effect to action shots is a simple yet effective way of making tracks and environments appear steeper and more exciting. Do this quickly using the Crop tool, drawing your intended area to crop, then with your cursor outside of the selection, a double-headed arrow will appear enabling you to tilt the crop as necessary. Double-click inside the crop when you're happy.

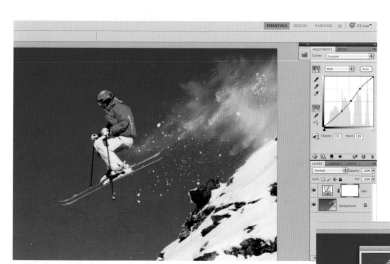

STEP 6 To boost the overall colors and contrast, I created a Curves adjustment layer (Layer > New Adjustment Layer > Curves). For this shot, a gentle S-curve increased the contrast accurately, further enhancing the blue sky and skier. As always, finish by sharpening your image. Smart Sharpen is good for action shots as it gives you more control. Select the Background layer and go to Filter > Smart Sharpen. Set Amount to around 80 percent and Radius to 1.2 pixels, set Remove to Lens Blur if necessary. Click OK and save the image.

PHOTOSHOP GUIDE—ADVANCED TECHNIQUES

Clients will often make specific requests when it comes to editing and processing images. It's up to you to have the necessary Photoshop skills and be able to deliver professional-quality results when asked.

You will often need to batch-process a series of images from the same shoot. Knowing how to do this can save you hours of image-editing time, as well as giving you the advantage over competitors if you can produce finished images quickly for clients.

You may be asked for a contact sheet of all the images from a shoot so that the client can view the shots and pick favorites for you to process. The great thing about creating contact sheets is you can save them as JPEGs and email them to speed up the process.

In this final section we'll reveal pro secrets for batch processing multiple shots, how to create contact sheets, as well as advanced techniques for enhancing your shots, and presenting your images in a triptych format.

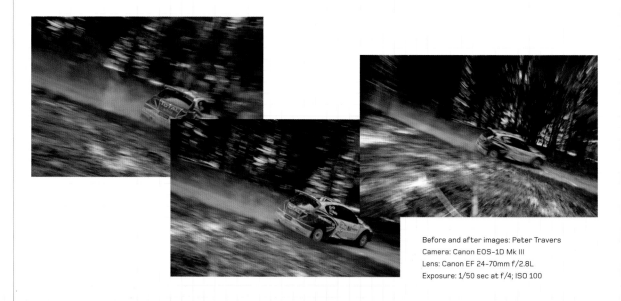

Before and after images: Peter Travers
Camera: Canon EOS-1D Mk III
Lens: Canon EF 24–70mm f/2.8L
Exposure: 1/50 sec at f/4; ISO 100

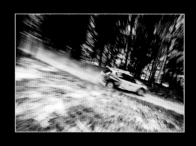
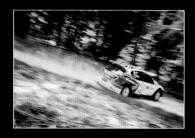
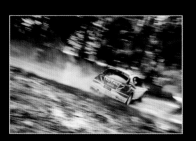

STEP 1 To create a contact sheet, go to File > Automate >
Contact Sheet. Choose the folder with the images in, and
set the document size. Set the number of thumbnails per page—
between 3–5 per column/row is best otherwise they'll be too small to
view. Don't forget to tick Use Filename As Caption or else neither you
nor your clients will be able to identify images easily. Click OK.

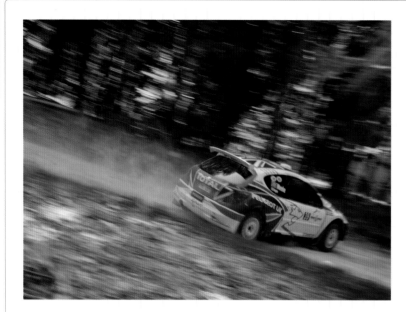

STEP 2 To batch process multiple RAW images, I've opened a series of rally car action shots in Adobe's Camera Raw editor. This is a great way to process multiple images of the same subject or scene. Process your first image, adjusting White Balance, exposure, contrast, saturation, and remove any dust spots and so on.

STEP 3 On the left-hand side of the RAW editor choose Select All, then click the Synchronize button. You'll then get the option to unselect certain settings—such as Fill Light, Crop, and so on—and press OK when done to synchronize your enhancements. With the all images still selected, click Save Images to save the batch as JPEGs or TIFFs, or click Open Images to launch images in Photoshop for further editing. As we're planning to create a montage of shots, we selected Open Images.

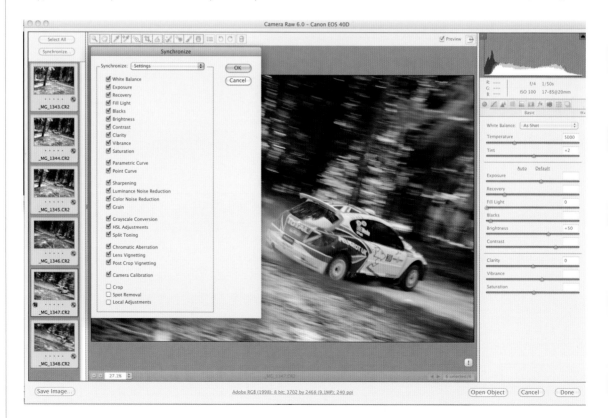

STEP 4 A great technique to master for advanced Photoshop users is the Transform tool. Usually used for straightening buildings and vertical lines, we're going to use it to emphasize the size and shape of the car. Press Ctrl/Cmd+A to select the whole image, then go to Edit > Free Transform. Within the Transform submenu are many options including Scale, Skew, and Warp, but here we've selected Distort. Use the anchor points and drag to resize and reshape your subject. Click the tick in the Tool Options bar at the top of the screen, and press Ctrl/Cmd+D to deselect when done.

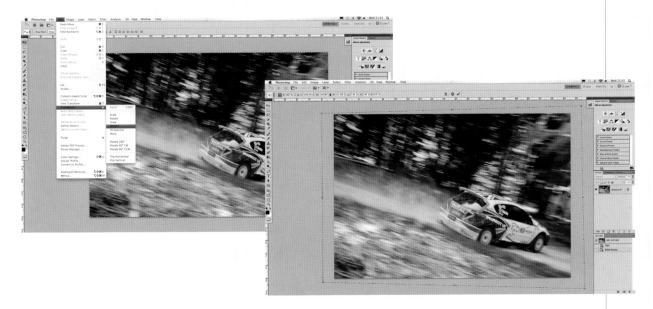

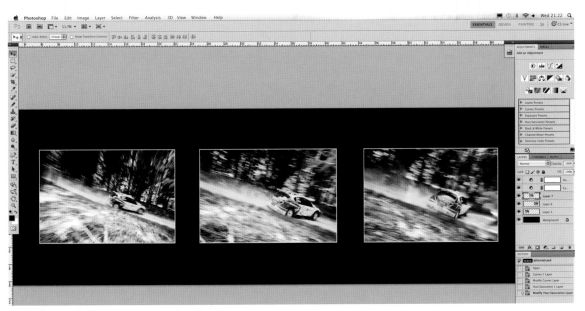

STEP 5 Triptychs are a great way of presenting multiple images. Open your processed images, and first add a thin white border to each image. Go to Image > Canvas Size, set Canvas Extension Color to White, then extend the Width and Height by 0.2in (5mm) for a 0.1in (2.5mm) border. Click OK. To place the three images evenly on a black background, go to File > New, set your height and width. Click OK. Go to Edit > Fill and set Contents/Use to Black. Now use the Move tool to simply drag, drop, and position, your three images on the black background.

← 184
→ 185

IMAGE PREPARATION

For most images we get printed for our studio products, frames and prints are prepared in RGB (Red, Green, Blue) color space, but when magazines print images or commercial copy is needed, they will require images with a CMYK color space (Cyan, Magenta, Yellow, & Black) embedded in them. To convert images from RGB to CMYK in Photoshop, go to Image > Mode > CMYK Color. Alternatively, go to Edit > Convert to Profile and choose the CMYK destination space.

Using the first conversion method can change the color hue of your imagery (leaving images looking a little flat), so make sure you assign a CMYK profile and then work on the image enhancements in Photoshop afterward—otherwise you maybe in for a shock when you assign the CMYK profile at the end of your Photoshop work.

My photographic style is quite unique and my images are often punchy and full of color. My clients know this but on occasion I am asked for different styles, such as muted colors or a certain Photoshop treatment

High resolution
Most of my prints are sent out at a 300dpi (dots per inch) image resolution, however some clients require different resolutions so make sure you find out what is required: for instance, my photo album company print at 240dpi.

If the client requires proofs or contact sheets quickly then I will send out files as low resolution at 72 or 150 dpi. This means that they are small enough to email and open quickly, but crucially, still with enough detail and image quality to see clearly. When you save your image, go to File > Save for Web & Devices. You will see the original on the left and the downsized image on the right so you can check the image quality before saving.

Top > Magazines and commercial printers require images to be converted into CMYK color space.

Middle > Check with your clients or printers beforehand to see which resolution they prefer images to be saved in.

Above > Learn how to save your images as low-res files so that clients can quickly view your shots in emails.

Image format

There are many ways to save final images depending on the usage and output. JPEG is a compressed file format and this is often used in advertising or magazine work as it allows sufficiently high resolution in more manageable file sizes. And quality won't suffer as long as the file is saved at maximum quality (lowest compression) and only used for output—that is no further image-editing occurs to the JPEG.

TIFFs are popular among Apple Mac users, graphic artists, and the publishing industry. While PSDs are proprietary to Adobe Photoshop. PSD files are useful as they retain any layers created when making enhancements, and can be returned to time and again, although they will eat up computer space due to their large size.

Disc or FTP

Once you've determined what your client needs, how do you go about getting the large images to them? You can, of course, burn them to a CD or DVD and post them. This is what I do as a matter of course with commercial clients. However, for a speedy response I can upload to the client's FTP (File Transfer Protocol) site. Most clients have their own FTP servers, which I can simply drop the images onto.

I also have my own iDisk address on the Mac from which (with a username and password) my clients can easily retrieve images. There are also many online companies you can use for free up to a certain upload size to get your files to your client quickly and efficiently—such as YouSendIt (www.yousendit.com), which is free for files up to 100Mb, or a small monthly fee for files up to 2Gb.

Know your clients

Make sure you get all the information you can from your client, not only what they require from the shoot, but what they want/expect from the finished files. Make sure you find out how the images will be used. If the client wishes to produce large billboards, then you may have to use a medium-format camera or high-megapixel digital SLR at low ISOs to get the large file sizes, image quality, and resolution they need. However, if the client is using images as low-res for web-only, then you can shoot accordingly. Know your client, know their needs, and you can't go wrong.

Top > Always ask clients which file format they prefer—RAW, TIFF, PSD, or JPEG files.

Middle > There are many different ways to deliver hi-res images to clients, such as FTP servers.

Above > If you and your client use Apple Macs, use the built-in iDisk to send images easily.

RESOURCES AND PHOTOGRAPHERS' CONTACTS

B&H Photo Video www.bhphotovideo.com

Canon www.canon.com / www.canon-europe.com

Digital Photography Magazine www.dpmag.com

Digital Photo Pro Magazine www.digitalphotopro.com

Elinchrom www.elinchrom.com

The Flash Centre www.flashcentre.com

Hassleblad www.hasselbladusa.com / www.hasselblad.co.uk

Lastolite www.lastolite.com

Nikon www.nikon.com / www.europe-nikon.com

Park Cameras www.parkcameras.com

Phase One www.phaseone.com

PhotoPlus and Digital Camera magazines www.myfavouritemagazines.co.uk/photography

PhotoRadar www.photoradar.com

Pocket Wizard www.pocketwizard.com

Professional Photographer Magazine www.ppmag.com

Sigma Imaging www.sigmaphoto.com / www.sigma-imaging-uk.com

Snapperstuff UK www.snapperstuff.com

Warehouse Express www.warehouseexpress.com

CONTRIBUTING PHOTOGRAPHERS

Action photographer, Dan Milner

www.danmilner.com

Food photographer, Ivor Innes

www.innes.co.uk

Interiors photographer, Enrique Cubillo

www.85photo.com

People photographer, James Cheadle

www.jamescheadle.com

Product photographer, Jonny Gawler

www.flowimages.com

INDEX